MW00713196

Volunteers:
America's Hidden Resource

Rosalie Rosso King
and
Jacquelyn Fluke

UNIVERSITY
PRESS OF
AMERICA

Lanham • New York • London

DEDICATION

To the Volunteers and especially the Professional Volunteers who have accomplished so much through their work and actions to improve their communities, we dedicate this book.

We also must include two special people who diligently supported our volunteer efforts, our husbands, John and Dell.

Jackie and Rosalie

ACKNOWLEDGEMENTS

We would like to thank those persons who were both generous and helpful in providing and sharing information and their experiences which helped form the direction we took in this book. Specifically, we would like to thank all the Professional Volunteers who gave us their time and input. Also, we would like to thank:

Carolyn Bockhorst, Chairman, **Concours d'Elegance**, Louisville, Kentucky,

Elizabeth Eickman, Director, **Festival of the Arts**, Oklahoma City, Oklahoma, and

Judith Whetzel, Executive Director, **PONCHO**, Seattle, Washington.

WHY WE WROTE THIS BOOK

"Where do you work?"

"Well, I don't formally work. I am a Professional Volunteer."

"Pardon me?"

"I work for the arts on a Professional Volunteer basis."

"Oh..."

Conversations such as these point out that although volunteerism has been gaining in recognition, it may well be emerging as a primary vocation. Volunteerism has worth. Volunteerism has meaning. Volunteerism accomplishes goals that are attainable in no other way. Volunteerism makes a difference.

Volunteers perform their function for many reasons but the truly committed arts volunteer believes and deeply appreciates the beauty the arts bring to everyday life.

Volunteerism is the critical tangible evidence that a community cares enough about its future that its citizens give of their time to make their community better... with no other remuneration, the volunteer works only for the satisfaction derived from unselfish contribution.

In times of great prosperity, funds from government tend to insulate a community from the real source of its vitality - the people who give the community its character. When times are tough, it is this underlying character that surfaces. And it is this character that determines the fate, over the long term, of the community. The essence of this character is always expressed by the community's

volunteers -- who they are, their skillfulness in picking the right causes, their creativity in mustering the community's patent resources, their balance between basic welfare, health, education and cultural initiatives. Just as we all can describe others we have known in terms of their personality and deportment... well rounded or shallow, for example... we can also describe a community in analogous terms. In the final analysis, if a community cannot develop a well-rounded "personality," it may well condemn itself to a stunted future that grows slowly, if at all in good times, and suffers more deeply in bad times than communities with fully developed personalities.

This book explores the role of one particular category of volunteerism -- the volunteer who supports the arts. All types of volunteers are important to the community, but volunteers for the arts are frequently the least appreciated, yet may well be the most instrumental in conferring an aura of polish and state of achievement on their community that even the arts volunteers themselves can only vaguely sense. In the course of the chapters that follow, the authors hope to convey a supportive argument for just how important volunteers are in general, and, specifically, the contributions made by volunteers for the arts.

Finally, there is a particular class of volunteer who will be called the Professional Volunteer, who becomes especially effective at marshalling the volunteer resources in a community. We as authors will build a strong case for the notions that volunteers are a special kind of professional who possess unique talents that simply cannot be purchased at any price. Yet, many of the qualities used by these Professional Volunteers can be continuously developed... their compensation is a community that is better because of their efforts.

OUR DEFINITIONS FOR THIS BOOK

So that we are all "speaking the same language" and understand each other, definitions used in this book need to be stated so we all share a common beginning.

Volunteer

The voluntary sector is that essential component of society which can experiment, demonstrate and innovate; monitor the public sector objectively and impartially; influence governmental program development, and provide those services unmet by governmental programs. Voluntarism demonstrates citizens' responsibility for society's institutions. Only through the participation of persons who lack vested interests will the process of institutional self-renewal be generated.[1]

Professional Volunteer

Within most volunteer projects there is an easily recognizable volunteer who is found to approach his cause with extensive professional qualities, hence he earns the term Professional Volunteer. The Professional Volunteer carries many of the same attributes as those of the professional lawyer, businessman or researcher; this person manages time, delegates work loads, possesses a special ability for finding the right person for the right task, makes decisions based on reason rather than emotion, and evaluates past projects' outcomes realistically in order to bring increased positive results. This person is able to break large goals into manageable tasks. Patience, perseverance and positive faith that the project will be successful appear to be an inborn part of this individual. The Professional Volunteer manages with outstanding ability, whether it is his own time or that of the entire organization.

Art

Art is everywhere, it is expressed in the buildings we inhabit, the stories we read, the music we sing, the films we see, the knicknacks we place on our shelves, the photographs we take, the paintings we hang on our walls, the patterns we have on our bedspread, the shape of our pottery, the landscaping of our parks, and the choreography of our work and play.[2]

Arts and Cultural Organizations

The arts and cultural organizations include public radio and television broadcasting organizations, non-profit theatres, symphony orchestras, operas, dance companies, museums, and botanical gardens.[3]

Formal / Informal Volunteering

Informal volunteering is usually volunteering that is done by oneself, alone, in a less structured and defined manner. Examples are babysitting, housecleaning for an elderly person, or grocery shopping for an invalid. Formal volunteering is usually done as part of a group in a more structured environment or organization.

Independent Sector

That portion of our economy that is not governmentally related nor run for profit; often referred to as the non-profit sector. The independent sector represented approximately 4.2% of all institutional entities operating in the United States in 1984. There were approximately 821,000 reported entities in that year.[4]

In 1980, an organization was formed whose goal was to "create a positive national climate for giving, volunteering and not-for-profit initiative." The name of the organization is Independent Sector. It is an umbrella organization of more than

650 corporate, philanthropic and special interest organizations. It is composed of an incredible variety of American Institutions - libraries, museums, universities, the United Way, orchestras, garden clubs, hospitals, Alcoholics Anonymous, 4-H Clubs, and on and on.[5]

REFERENCES

From the Preface: Why We Wrote This Book, Definitions

[1] The Association of Junior Leagues, Inc.

[2] Shaping Policy on the Arts (American Town Meeting on the Arts in Washington, D.C.) W. Yates, Chr. Cent. 98: 1046-8, October 21, 1981.

[3] Dimensions of the Independent Sector: A Statistical Profile, V.A. Hodgkinsons & M.S. Weitzman, First Edition, p. 63.

[4] Ibid, 1986, p. 3.

[5] Independent Sector Annual Report, 1981, p. 13.

INTRODUCTION
AMERICA'S HIDDEN RESOURCE - US!

America has a hidden resource. It is a resource of strength that has only recently begun to be tapped. This resource is the use of volunteers -- those persons who give of their time, talent and loyalty, yet receive no monetary reward. The rewards these people receive come in many other, often complex, ways.

The uniqueness of this hidden resource is that the American volunteer fills the gap that is predominantly a state function in other countries and cultures. American volunteers have become essential to our nation and with increased and better structured organization they can assure that total reliance on government sources will never be necessary.

In "American Philanthropy and the National Character," historian Merle Curti states, "Emphasis on voluntary initiative... has helped give America her national character... All the philanthropic initiatives give support to the thesis that philanthropy has helped to shape national character... (by) implementing the idea that America is a process rather than a finished product." [1]

Development of America's Unique Resources

While exploring the entire area of volunteering for the arts, it became fairly well established that volunteering appears to be an American phenomenon. In *Democracy in America*, de Tocqueville observed that Americans take pleasure in seeing "how an enlightened self-love continually

leads them to help one another and disposes them freely to give part of their time and wealth for the good of the state." He continues that "Americans of all ages, all conditions, and all dispositions constantly form associations. They have not only commercial and manufacturing companies, in which all take part, but associations of a thousand other kinds, religious, moral, serious, futile, general or restricted, enormous or diminutive. The Americans make associations to give entertainment, to found seminaries, to build inns, to construct churches, to diffuse books, to send missionaries to the antipodes; in this manner, they found hospitals, prisons and schools. If it is proposed to inculcate some truth or to foster some feeling by the encouragement of a great example, they form a society. Wherever at the head of some new undertaking you see the government in France, or a man of rank in England, in the United States you will be sure to find an association."[2]

The existence of the independent sector is a wonder to behold in a country often accused of greedily pursuing the dollar and wallowing in materialism.[3]

Comparison: International Volunteerism

According to Theodore H. Hesburgh, President, University of Notre Dame, 1952-1987, "we take voluntarism so much for granted in America that its importance is really not appreciated until we compare our way of life to that in countries where everything is of the state, by the state, and for the state."[4]

He continues, "one might make the point more forcefully if this interesting question were posed. Suppose that tomorrow the most expensive

multibillion dollar endeavor in our land, the federal government, were to suddenly be inactivated. What would be the effect, the impact on your life? It is suspected it would be enormously less than if all voluntary associations were suddenly eliminated."

In many other countries, volunteerism for the arts has not occurred due to the fact that the arts have had a centuries-long tradition. Perhaps that alone is why these countries appear so far advanced in recognition of cultural development related to the arts than in the United States. In the countries where it was possible to make contacts, resources for development of the arts appear to be from three main sources. These sources of support include: 1) religion based sources, 2) gifts of wealthy patrons, and 3) direct support by the state governments.

In looking at the state of the arts, the middle ages of Europe brought the well-known support of the arts by the wealthy ruling class. The Medicis of Italy were responsible for the support and encouragement of many of the painters, sculptors, and artisans of their period. The European world would not be what it is if this patronage system had not been available. However, this system of arts support is not limited to Europe of past times. Today, almost every geographic area, every region, and every city, has citizens of means who take a special responsibility to make the world a little better by supporting the arts through direct contribution.

In many countries, one branch of government directly supports the arts. When this is the case, the arts are often well funded, well developed and appreciated by the citizenry. For instance, many of the communist

countries directly support arts such as ballet, museums and the development and placement of statuary. The basis for this support is the concept that the government is for the people and since the people work directly for the government, the government should be responsive to all the people's needs. One cannot travel through a strong governmentally controlled land without being made aware of heroes of the state; these persons are usually seen again and again in plays and statuary. In addition, contemporary arts in these countries may serve as propaganda for the government.

Obviously, the United States is not the only participatory society in the world. Giving, volunteering and nonprofit organizations exist in many countries, but nowhere else are the numbers, proportions and impact so great.

The comparative studies are sketchy, but what facts there are indicate that this country's degree of organized participation is unique. In a recent speech, "A Global View of Philanthropy," J.D. Livingston Booth of Great Britain, President of Interphil (International Standing Conference on Philanthropy) said, "Outside the United States there is very little recognition that an independent voluntary sector even exists, let alone that it has a wholeness, a role, and a significance in free societies."[5]

De Tocqueville was right when he said "what political power could ever carry on the vast multitude of lesser undertakings which American citizens perform every day?"[6]

Sweden

The importance of the need for volunteers was recently established in a report by the Swedish Secretariat for Future Studies.[7]

The Secretariat sets the stage for Sweden's future policy and recommendations from the Secretariat are almost always incorporated into Swedish law. The Secretariat is the Swedish version of the American Presidential Commission or the British Commission of Enquiry.

"Care and Welfare at the Crossroads," the report issued by the Swedish Secretariat, concluded that the social contract of the modern welfare state is going bankrupt. The problem is not that more people will require care, but that the hourly wages of care providers will exceed the system's financial capacity. Today in Sweden an estimated 14% of the Gross National Product is committed to health care. The Secretariat estimates that 20% will be committed to health care by the year 2,000 with an estimated 60% of the GNP going into taxes. The Secretariat feels that raising taxes is not the solution to this problem nor is reducing the quality or quantity of care. The solution for the Swedes is to "invent" the independent sector with volunteerism becoming mandatory. The Secretariat recommends that everyone aged 19 to 65 be required to give four to six hours of care a week.[8]

Why You Should Read This Book

America needs people willing to work for the arts, or health issues or educational projects or social concerns. Yet, when we began to gather information for this book in support of America's volunteer, we found studies of volunteers and in particular, volunteers for the arts, were missing.

Volunteers in other parts of society, such as education or in medically related causes, can and often do have relatives who benefit directly from their volunteer efforts through such means as increased support for specialized reading classes or successful research projects. The volunteer for the arts basically supports causes that the *entire* population can enjoy, whether it is associated with the symphony, theatre, opera, art museum or dance organization. Recognition for that segment of the population whose accomplishments yield silent yet steadfast support for the arts is long overdue.

Equally important is the need to recognize that the ability to volunteer with measurable accomplishments can become reality; you can achieve those plans of action that are important to you. The underlying goal of this book is to give encouragement by offering examples that have worked when matched with the desire of people to achieve certain results. Necessary as well is a generous amount of creative imagination and energy!

Although Professional Volunteerism in this book concentrates on supporting the arts, many of the principles and philosophies can apply to other areas of volunteering as well. Identifying and giving recognition to the true value of America's volunteers is the entire purpose we hope to achieve.

This book will also offer some "how to" principles and information. Our intent is not to give an oversimplified structure for organizations, teach recruitment of volunteers, nor give suggested methods of solicitation by boards of trustees. It's purpose is to make you --the volunteer -- proud of your contribution and to give you the much needed "pat on the back" you deserve. It is for the person who wants to volunteer, to cause you to reflect on how well you can organize your volunteer network and how effectively you will use this vital resource now and in the future. And it is for our society as a whole to help us all recognize both the uniqueness and the necessity for our volunteer segment -- how many of us are working together to get so very much accomplished.

The Steps in This Book

The following statements reflect the basic concept of each chapter in this book. Although each chapter both deviates and expands from its concept, the statements will allow you to see the direction this book will take.

Taking A Look Back at Volunteers in Our History

> The demand for volunteers in terms of both numbers and hours will continue to increase as the reliance on volunteer efforts to close the gap between earned income and total costs of arts organizations continues. Chapter one discusses volunteering and contributed income for the not-for-profit Independent Sector in America's past and in America today.

Why People Volunteer

The act of volunteering for a just cause may be part of the definition of being an American. People volunteer for many reasons -- most important of which is a feeling of increased identity within the community and a desire to give back to the community. This chapter looks at the psychological implications associated with increasing one's self worth through volunteerism. This chapter also discusses how society gains by group enrichment rather than by personal rewards, by having the quality of life enhanced for all citizens of varying culture, experiences and ethnic origins through our nation's volunteer efforts.

Fund Raising

Much of our increased understanding of volunteers, professional volunteers and arts organizations in general came from indepth questioning and study of five specific not-for-profit organizations and endeavors. These five areas of concentration are detailed in Chapter three to give the reader the opportunity to see the source of some of our information and conclusions and, in addition, perhaps find new ideas or concepts which may be helpful in individual fund raising.

How to Organize

A logical management based approach for arts funding needs to include emphasis on researching events, development of long range program goals and evaluation of volunteer performance after the event is held.

Techniques borrowed from the business world will incorporate the principle of optimum planning supported by extensive investigation to determine the best way to accomplish goals. This will be followed by extensive evaluation so that meaningful recommendations can be made to insure greater successes.

Future Trends and Emerging Roles

As the sophistication of the volunteer of the late 1980's early 1990's increases, so too does the masnagement and the training of that volunteer. What was once a nation of unorganized volunteers raising barns, holding garage sales and running PTA's is now emerging as an organized, well-trained and highly sought-after entity of devoted workers. Along with increased professionalism in our volunteering, increased use of professionals in consulting and fund raising is a direction the arts have chosen. Both new breeds of volunteers and professionals are discussed in Chapter five.

Volunteers and Professional Volunteers

Two classifications or levels of volunteers -- the Volunteer and the Professional Volunteer -- emerge from most ambitious projects. The Professional Volunteer is that special individual who is as dedicated to carrying out the arts project as is the person who is employed for financial return. The Professional Volunteer is committed to the project, believes in its importance and sees it through, often under changing conditions. The Professional Volunteer is as proud of the work accomplished -- the planning, organizing, physical labor tasks, the evaluation -- as any employed professional is of his/her accomplishments in the business world. The

problem most Professional Volunteers face is that they rarely admit, or possibly do not realize, that committed volunteering is a profession in itself!

What makes a person volunteer? What makes one person volunteer more than another? Because little objective data existed, we decided to study them. The study included a personal interview with an identified Professional Volunteer and an open-ended written questionnaire. From these studies it was recognized that within a volunteer project there is an easily identifiable "super volunteer". By studying these individuals who were extraordinarily committed, it was apparent that the appropriate term for them was Professional Volunteers.

An intensive effort was made by the authors to better understand and evaluate this "unpaid professional". With the hope that society would better appreciate these unique and dedicated people, the study was also undertaken to:

1. Investigate if the value per contributed hour of the Professional Volunteer could be determined;

2. Discover what motivates these volunteers to donate time on a regular basis;

3. Learn more about their background to better understand the influences which helped produce their zealous commitment;

4. Quantify the extent to which arts organizations depend on the Professional Volunteer for reaching their annual fund raising goals.

As defined earlier, the Professional Volunteer carries many of the same attributes as those of the professional lawyer, doctor, businessman or researcher. This person manages time well, delegates work loads with a special knack of finding the right person for the right task, makes decisions based on reason rather than emotion, and evaluates the objectives of past projects in order to bring increasingly positive outcomes. This person is able to break down the overall goal into manageable tasks. Patience, perseverance and faith appear to be part of the makeup of this individual.

Professional Volunteers: What Makes Them Professional?

We identified the Professional Volunteers by their written survey responses, and then they were interviewed.

1. *Experience*

Of those in our review of Professional Volunteers, 67% had volunteered for at least 10 years with 53% having volunteered 15 years or more.

2. *Organization*

Half of those identified as Professional Volunteers commented on their own organizational abilities. These volunteers enjoy organizing and planning to see a project through *to its end*. They expressed an intensely pragmatic sense of "the end justifies the means" in that there

was no limit to which they would not go, no donation they would not seek, no contact they would not make to meet their goal.

As explained by Ann Ruebeck, a Professional Volunteer from Indianapolis, "I like to help to put the puzzle pieces together to make a completed project."

In their opinion, being a good organizer included effective *delegation* of responsibilities. It also involved attention to *detail*.

3. *Ability with People*

Nearly 60% made note of their ability to motivate and stimulate other volunteers. Carolyn Bokhorst from North Carolina, sensitive to other volunteer's needs, stated that all volunteers are much more willing to give when they are shown sincere appreciation for their efforts. Lenore Rukavina of Minnesota reflects that "when people power is essential, one must instill the belief in potential volunteers that what they contribute will make a difference. This is where my strength lies." Not only do Professional Volunteers receive cooperation but they cooperate with others; their volunteerism involves much give and take. As expressed by Mary Ann Champion, Seattle, one of the skills she has gained through her volunteerism is a "sharpened focus on others' talents."

4. *Commitment*

This strength surfaced repeatedly in many forms. It is the positive feeling that anything can be accomplished once a project is begun, the

acknowledgement that it is important to be involved, and the belief that a democratic society needs to pass this volunteerism commitment on -- generation to generation.

Carol Wilkinson, Oklahoma, states that the major reason she feels effective as a volunteer is due to her commitment to getting the job done -- and done as well as possible. Commitment comes about through the belief that these Professional Volunteers hold that what they do *can* make a difference. Carol continues, "It is nice for me to feel that my volunteer efforts can effect positive change".

5. *Personality*

Professional Volunteers are dynamic people -- they are leaders, they are managers, they are influential, they are confident. They are never too afraid to ask for help: they ask, they implore, they convince. They resist the small jobs for the more complex and stimulating growth found in larger projects. If it is not a challenge, they are not as interested. Most of these volunteers have built community contacts and established such a positive track record that they act as consultants for other organizations, offering fund raising ideas and the use of their management skills. They do not seek; they are sought. One Professional Volunteer, Faye Sarkowsky of Seattle, stated that she had interviewed many professionals for career positions and found that she had as much if not more background, expertise and on-the-job experience as many of the job applicants. Our study asked the Professional Volunteers to give one word about themselves as Professional Volunteers. Self-described they are: energetic,

19

committed, able, grateful, dedicated, dynamic, leaders, facilitators, and aggressive. The two most commonly used adjectives were "committed," and "dedicated."

It should be pointed out that volunteers and Professional Volunteers can perform each others role by switching back and forth. You have done that -- sometimes you are in charge and sometimes you are a smaller part of a larger project. Just remember this: Volunteers are no longer the icing on the cake. They are part of the batter. Many projects, in fact we would venture to say most projects, would not materialize at all without the dedicated effort of those who willingly give of their time.

Nor should volunteering be exclusive to those without paid regular employment. It is an important responsibility and additional opportunity for the career person. In fact, the national 1983 Gallup Survey conducted by the Gallup Organization on the nature and scope of volunteering in the United States identified that the largest portion of adults who volunteer are professional and business people, and for the most part those with higher incomes volunteer more than those with lower incomes.[9]

The career person may have greater need to give back to the society from which he/she takes paid employment. This individual can usually offer special assistance in their own professional discipline, or experience relief from monotonous daily schedules, achieve more autonomy, or practice management techniques. In short, the career person can discover a balance by giving of themselves for the community.

Dilemma or Opportunity

In discussion after discussion with volunteers, two questions emerged:

1. Why has American society made a person feel guilty who volunteers their time and talent for the arts versus an established educational program or medical cause?

2. Why is paid employment the major measure of one's worth to society? Why is the main recognized form of reward related only to currency?

Most likely if you are reading this book, you are a volunteer. But perhaps you are a "closet volunteer" -- afraid to tell your husband (wife, friends, co-workers) that you're going to a meeting to brainstorm fund raising ideas, leery of informing mother-in-law why you're not home with your children, embarrassed to admit to working so diligently and not having a title or paycheck.

Most people at varying times of their lives have the desire to help mankind by giving their time and energy for a cultural cause whether it be music, art, dance, drama, literature or philosophy. Yet volunteering is shrugged off by many of the populace as being an unimportant pastime.

This should not be! And since we are delegating blame, let's first start with ourselves. Step out of that closet and declare yourself a Volunteer! Break down the fallacy that because you give something (your time and talent) for nothing (no pay), it has little value. You have an obligation to take yourself seriously.

To volunteer is to stand on your own, to "be" something, rather than a *reflection* of your mate or your children, your corporation, your parents. Through volunteering we can all discover our hidden talents for management, negotiating, supervising and administrating. We can indulge in experiments to "find ourselves" or is it better said -- to *define* ourselves.

All volunteer work is vital and relevant. We have chosen to write about the arts because we feel additional pressure is put upon these advocates both by society and by the press. However, we certainly recognize the need for volunteers in health and education areas as well. Volunteers for the arts generally are considered to be above the average in income and education level. Because they tend to have more money and more comfort in their lifestyles, society extrapolates that arts volunteers care little for the basic needs of the less fortunate -- food, shelter, employment. Why does it matter which group volunteers for which organization -- *it all needs doing*. The arts answer a basic need in all humanity -- the need for beauty, joy and harmony, an expression of culture. How blessed America is that we have such a vast array of museums, symphonies, dance and theatre and how fortunate that we have citizens concerned with their future. We found in our efforts that people who volunteer for the arts also volunteer for approximately 2 (1.7) other organizations with the majority interested in civic community work, specialized medical needs (heart, research, cancer) and medical needs of children. The primary motivation behind their arts volunteering is that they *believe* in support for the arts.

The necessity of using volunteer efforts for hours of work and monies raised will continue into the future. However, the needs are going to

increase and the methods used by volunteer efforts will evolve into new avenues. Corporate donations may match the Medici's of old, but still will not meet the increasing need.

New specialized professionals are being educated through Arts Management Bachelor and Master programs of study which emphasize the ability of using professional fund raisers and legislative arts advocates to bring large funding commitments to arts causes. The volunteer coordinator, a person who specializes in matching a person and his or her interest to the job needing to be done, is a new area of specialization. By matching person to task, a volunteer is more likely to be kept interested and feel the work is indeed worthwhile. Volunteers may request specific experiences through regional volunteer registries.

However, most important in the future will be the recognition and the appreciation of the Professional Volunteer.

VOLUNTEERS ARE THE SOLUTION

The Challenge

Society today does not and cannot pay everyone for all the jobs that need to be done. Resources are limited. People who volunteer, whether they are the Professional Volunteers or whether they are persons who volunteer by giving of their more limited time to facilitate the completion of a project under the guidance of a Professional Volunteer, are an important ingredient for the successful functioning and ongoing development of society. Appreciation for the arts in all forms is expanding yet available resources are being spread over a larger number of arts organizations. Other avenues of support need exploring, therefore increased use of volunteers, and the use of these volunteers at higher activity or task levels, may be the answer or a partial solution.

REFERENCES

Introduction

[1] *Origins, Dimensions and Impact of America's Voluntary Spirit*, paper by Brian O'Connell, Independent Sector, p. 7.

[2] de Tocqueville, Alexis, *Democracy in America,* Vol. II, Chapter 5, 1945, p. 114.

[3] Doyle, D., *Socialist Sweden Tries to Reinvent Philanthropy*, Wall Street Journal, April 17, 1984, p. 34.

[4] Hesburgh, Theodore H., "Reflections on Voluntarism in America," April 21, 1980.

[5] *Origins, Dimensions and Impact of America's Voluntary Spirit*, paper by Brian O'Connell, Independent Sector, p. 3.

[6] de Tocqueville, Alexis, *Democracy in America*, Vol. II, Chapter 5, 1945.

[7]Doyle, D., *Socialist Sweden Tries to Reinvent Philanthropy*, Wall Street Journal, April 17, 1984, p. 34.

F[8] *Ibid.*

[9] *Giving USA,* 1984 Annual Report, American Association of Fund Raising Counsel, Inc., p. 98.

CHAPTER ONE

HISTORICAL AND CURRENT INFORMATION ON THE ARTS

The history of the relationship of volunteers and the arts is intriguing. Volunteering today originated, developed and has been refined in America. To give us a perspective of where the arts are today, a look at the past is helpful.

Our Past Support

Fourteen years ago, Amyas Ames, the 1975 Chairman of the National Committee for Cultural Resources, reported the following conclusions from the Committee's 1975 Study of the Arts. Even though these conclusions are for the arts the implications for all volunteers are important.

1. There has been a steady rise in the interest of the arts in the last decade. This strong interest continues to rise.

2. "The arts are a growth industry."

3. Strong positive attitudes are held by Americans regarding the arts and the need for their support.

4. An important role in the nation's economy is played by arts organizations.

5. Although the arts are playing a larger role in American life, there is cause for concern regarding the future of organizations which provide the arts to the public.

6. The public is being deprived and our cultural life weakened due to the fact that many arts organizations are being forced to drop planned, ongoing or expanded programs.

7. A public policy is established regarding government subsidy of arts organizations. The main source of support for the arts must continue to be local increased funding plus the public subsidy.

8. The National Committee for Cultural Resources recommended that federal aid should provide an average of no less than ten percent of the total cost of arts organizations throughout the country. It is also recommended that each state should provide an average of no less than ten percent of it's arts organizations operating costs.[1]

In addition to reporting on areas of financial support, the Ames work also touched on interest in the arts as measured by attendance at events. This early formal study brought to focus the misconception the public held during the 1970s that the arts were in an advantageous financial state when in reality the organizations were not. This misconception was also reported in the 1975 National Committee for Cultural Resources Report.

Financial Support - Philosophy of the 1970s

During the '70s, according to the report of the National Committee for Cultural Resources, one in ten Americans believed that museums were self-supporting and three in ten Americans believed that the ballet, opera and symphonies were self-supporting. The majority of Americans felt that profits were made by these arts organizations when in fact these not-for-profit organizations

were barely breaking even and, more often, losing money *(A Survey Of The Attitudes Toward and Participation In The Arts And Culture Of the United States Public)*.[2] This revealed a lack of communication concerning the true financial state of the arts between the arts organizations and the public.

This lack of communication was a warning signal which indicated that there was to be severe difficulty for the arts at a time when greater financial needs were necessary unless these organizations could find people who were willing to volunteer their time to fill the gap.

One of every two Americans felt that businesses and corporations provided financial support for the arts while the majority of Americans felt that private foundations were the proper sources of financial support for the arts. Four of every ten Americans felt that federal spending for the arts should be increased, while only one in ten Americans felt that federal spending should be decreased. Yet, through this time, a growing support for the arts was developing in the society by the people.[3]

In 1975, 41% of Americans reported that they were willing to pay an additional $25 per year in taxes to support the arts, 46% were willing to pay an additional $15 per year, and 51% were willing to pay an additional $10 per year. An estimated 87 million Americans (58%) were willing to pay an additional $5 per year to support the arts. This was a strong indication of public support for the arts fourteen years ago.[4]

If much of the money used for arts support is used for labor or services, then, time volunteered becomes an equally valuable measurement of support.

The 1970s closed with a gradual shift in the population's philosophical viewpoint from a liberal to a more conservative nature. Reality became more of a focus in the 1980s. Five years after the Ames National Committee for Cultural Resources Study, the 1980 Harris Poll indicated that the majority of Americans would support some tax increase to fund the arts. Most Americans were willing to support a tenfold increase for government arts dollars beyond the fiscal 1980-81 average total of federal state arts funding of about $1 per person. Most at the time surveyed felt that the arts were not self-supporting; were dependent on public and private contributions; and that the government should assist those arts organizations needing help. An incentive plan to stimulate private donations for the arts was favored by most Americans surveyed.[5]

So, evidence of public support for the arts was shown also by the Harris Poll. Along with an increased interest in the arts, there was an increased involvement and participation in the arts by Americans as measured by objective counts such as attendance. The National Committee for Cultural Resources Study found that public attendance at live arts events had increased. In 1975, 41% of those surveyed reported attending a live performance and went an average of 4.6 times the preceding year. Yet two years earlier, in 1973, only 32% reported attending a live performance and had gone an average of 3.5 times.[6]

Eighty-two percent of Americans felt that it was more meaningful and exciting to see a live performance on stage than to watch television. This suggested that the audience for the performing arts was expanding. If arts organizations were going to serve these expanded audiences, programs would have to become more numerous with increased expenditures and income to meet these expenses. The arts

29

occupied a significant place in the leisure time of Americans. Thirty-six percent of the Americans surveyed engaged in some type of arts activity. Surprisingly, in 1975, more Americans participated in arts activities than devoted time to sports activities (26%).[7] This further indicated the importance of the arts in American life.

Many Americans felt that the level of the arts activities available in their area was not sufficient. Eighty-six percent felt it was important to find some way to increase the performance of the arts in all parts of the country so that all Americans had an opportunity to attend.[8] This increased demand for the arts reflected the importance placed on the arts by Americans in differing geographic locales.

Arts Effect on the Quality of Life

There was an overwhelming conviction by the public that the arts improved the quality of life and contributed to the community's general health. In 1975, 93% of Americans felt that having arts facilities in the community was important to the quality of life. This is an increase from 89% of Americans who agreed with this statement in 1973.[9]

People believe that the arts are central to life in America. Ninety-one percent of Americans agreed that "things like museums, theatres and musical performances make a community a better place to live," while 84% ranked the arts as important for the community as libraries, schools, parks and recreation activities.[10]

An increasing number of Americans felt that the arts were important to the business and economy of the community. In 1980, 85% of Americans felt this way, compared to 80% of Americans in 1975.[11]

Just How Important Are We?

Volunteers -- and the time they spend helping organizations keep their costs within manageable limits -- have traditionally been an area about which little is known. Thanks to organizations like Independent Sector, the American Association of Fund Raising Counsel, Inc., and VOLUNTEER, statistics are now being generated which support the premise that volunteers are one of America's unique resources. These figures not only allow us to see the present and compare it to the recent past, but to observe the trends of volunteerism for the near future. The numbers are recent because it is only recently that volunteerism became recognized as an area of study that required quantification.

Fact: In 1968 twelve states had arts agencies. The agencies specialized in encouraging various facets of arts activities such as support for artists and increased funding. Today, art agencies exist in virtually every state. The expansion is directly attributable to the expressed desire of the general public for increased arts exposure -- a recent study found that *90%* of the adult population believe arts and cultural activities are an important part of their lives and the *lives of their children* (an important concept in a developed country). Unlike Europe, in which the arts are heftily supported by the government, the United States has been relying more and more on volunteers (*you*) to support this increased desire of the populace toward the arts. You are important to the volunteer effort!

Few surveys investigating volunteers have been done in the past due to the difficulty in defining which activities volunteering includes. For instance, volunteering may be as informal as baking cookies for a school fund raiser or as structured as donating professional expertise for a formal organization.

31

The 1983 Gallup survey defined volunteering as "working in some way to help others for no monetary pay." This was also the definition the 1981 Independent Sector Study used to define volunteering. The 1983 Gallup survey found that when volunteers were defined in this broad manner, 55% of adults (92 million) volunteered in 1982.[12]

However, based on a 1985 national survey conducted by the Gallup Organization, results showed that Americans 14 years of age and older, who volunteered, had declined slightly from 1981. Overall, an estimated 3.6 million fewer Americans volunteered in 1985 than in 1981. Though the total number of volunteers decreased to 89 million, they had increased their commitment from 2.6 hours per week to 3.5 hours in 1985. This amounted to a 27 percent increase in the total number of hours volunteered during the five-year period, [13] raising contributed volunteer hours per year from 12.7 billion hours in 1981 to 16.1 billion hours in 1985.

In the past, volunteer work was often thought of as something women did instead of income-producing work. Housework was hardly considered real work as the cleaning, cooking, laundry, sewing, and nursing required for even large families was all done within the comfortable confines of the home and did not bring in money. Volunteering brought opportunities to be outside the home, to do jobs no one else was available to do.

The person who volunteers without financial reward has the ability to measure his worth through other than monetary remuneration alone. A sense of accomplishment, a feeling of satisfaction or trying something new is often the

reward. Self-esteem will be generated when the volunteer brings together heart and mind. According to Alene Morris, President of the ID Center in Seattle, Washington, a career life planning counseling center for adults facing career or personal change, "We have trouble feeling proud of work for which we are not paid. Society places value on us. Work is work is work. We can still have job titles even if there is no pay."

Work for women today is no longer limited to the home. Over fifty percent of women are in the workplace and the women's movement has brought feminism into the political mainstream. Women continue to volunteer their time after the professional work day and housework is finished. This shift has caused the nature and definition of volunteering to be changed. Volunteering is now often related to a genuine self interest; its importance to the person is far more than release from the home setting. It is often diametrically different from one's paid employment. It often brings inner satisfaction by allowing intensive development or commitment to a personal interest.

Fact: The membership of The Association of Junior Leagues has risen from 109,000 members in 1974 to 172,000 in 1987. The number of incoming members working outside the home has increased which supports the information provided by the 1983 Gallup survey; more professional women are joining volunteer organizations. There has also been a rise in the age at which women are joining, from 21-22 in 1974 to 34 in 1987. This indicates a new trend of women volunteers and a new mentality of our volunteer network. The female volunteer of the 1980's organizes her life, establishes herself in home and career and begins her volunteer commitment as an *adjunct* to her existing lifestyle. She finds something missing in her life, a void, which can be filled by receiving back in proportion to what she gives.

She selects volunteer experiences that carry more responsibility and are more personally rewarding or challenging. In a time when fund raising is big business and more and more charitable organizations are clamoring for the same dollars, this trend is an asset to the not-for-profit organizations who are desperately seeking trained and experienced volunteers. Younger volunteers may need assistance or require training whereas older volunteers bring a background of needed skills to the organization such as managerial, fiscal or promotional abilities.

Fact: According to Wendy H. Borcherdt, Special Assistant to President Reagan for Public Liaison in 1982, $133,000,000 per day was contributed in volunteer time during 1981. This totaled $47.7 billion contributed in volunteer time per year. By 1986, the dollar value of formal volunteering had grown to $110 billion.[14]

Essentially the independent sector is labor intensive, since a large portion of its activities consists of providing services from people to people. Therefore, a large portion of the budgets of non-profit organizations is devoted to salaries and wages. The Independent Sector Analysis research shows that volunteers accounted for the equivalent employment of 3.3 million employees in 1977, 4.1 million employees in 1982 and 4.7 million employees in 1984. Had these 4.1 million volunteers been paid in 1980 their wages would have accounted for 4.1% of all paid wages in that year.[15] Profiles such as this shed considerable light on just how much of a role you as a volunteer and charitable organizations fill in the overall economy of the nation.

A 1981 Gallup Survey conducted on the nature and scope of volunteering in the U.S. found that 44% of volunteers worked on informal activities without organizational support such as local or neighborhood activities, 37% of volunteers

worked on religious activities, and 23% of volunteers worked on health activities. According to this 1981 survey, the main reasons people volunteer were that: someone asked them (43%); a friend or a relative participated or benefitted from the activity (25%); they were involved already in a particular organization (31%), or by seeking out the activity on their own (25%). It stated that 45% of all volunteers continue to volunteer in order to feel useful and to help others.[16]

In 1985, the Gallup Organization was again commissioned to survey volunteers, and found that the main ways volunteers first learned about the volunteer activity in which they worked were by participation in an organization (45%), by being asked by someone (39%), by having a family member or friend who participated in or benefitted from the activity (29%), or by seeking out the activity on their own (22%). An even higher percentage (52%) of Americans reported that they engaged in volunteer activity in order to do something useful to help others.[17]

Although volunteering occurs throughout the various population groups, there is a tendency for volunteers to fall into certain segments of the population. In 1981, for the total population, 56% of volunteers were women and of those, 36% had experienced some college education and 44% had yearly incomes of $20,000. The 1983 Gallup survey still found that 56% of women volunteered, but the number of men who volunteered increased from 47% in 1981 to 53% in 1982. The largest number of Americans who volunteered lived in the West (62%). This was followed by the East (55%), the South (54%), and the Midwest (51%).

Nearly half of all Americans 14 years and older contributed some volunteer work in 1985. The percentages of men and women who volunteered had decreased to 45 percent for males and 51 percent for females. However, two-fifths of

Americans who volunteered in 1985 reported that they were contributing more time in 1985 than three years ago.

Twenty-four percent reported that they were working fewer hours. The major declines among the percentage of volunteers between 1981 and 1985 have been among single persons (down 19%), persons with incomes between $20,000 and $40,000 (down 12%), persons between 18 and 24 years of age, (down 11%), and college graduates (down 10%). The largest proportion of volunteers in 1985 contribute time to religious institutions (48%), 40 percent contributed time informally (alone, non-organizationally), and 17 percent contributed time to educational institutions. Eight percent contributed time to arts and culture.

People who are very active or fairly active in their community are most likely to volunteer. Interestingly, weekly attendance at religious services also has an influence on the amount of volunteer activity in which one participates. Of the 44 percent of Americans who reported attending religious services nearly every week in 1984, 56 percent also volunteered.

Income affects our volunteering. Only 38 percent of persons with incomes under $10,000 volunteered, whereas 54 percent of persons with household incomes of over $50,000 volunteered. Those who are divorced, separated or widowed volunteered less.[18]

Funding

Because revenue is such a major consideration for all not-for-profit organizations, and because volunteers can play such an integral part in reducing the need for government dollars, a closer look at the available sources of arts funding

will give a better perspective of where volunteers can become involved and what roles they can perform.

The 1986 total donation of $87.22 billion given by private individuals, foundations and corporations went to more than 350,000 charitable organizations, institutions and agencies.[19] This amount is greater than the national budgets for over two-thirds of the world's countries. Of this $87.22 billion, the contributions were distributed as follows: Religion (46.9%), Education (14.6%), Health (14.0%), Human (Social) Services (10.5%), Arts, Culture and Humanities (6.7%), Public/Society Benefit (2.7%), Other (4.6%).[20] The $5.83 billion contributed to the arts in 1986, was up 14.8 percent from 1985. The growth was attributed to increased contributions from individuals, corporations, and foundations. The trend suggests that cultural groups are becoming more successful at securing funding, yet at the same time they are becoming more dependent upon unearned income.[21] In other words, volunteers doing increased and better fund raising.

Volunteers are more likely to make charitable contributions. The 1981 Gallup survey indicated that 91% of volunteers made a monetary contribution to an organization for which they volunteered or to another organization, while 66% of adults who did not volunteer made contributions. In 1984, the average contribution of volunteers was $830 and 2.8 percent of their household income, compared with an average contribution of $510 and 2.0 percent of income for non-volunteers.[22]

Funding - Individual Donors

American donors are found at all economic levels of society; all races, religions, ethnic backgrounds and in all occupations. Giving in America is not confined only to the wealthy or political families as in other countries. In 1984,

81 percent of Americans reported that they believed people have a responsibility to give what they can to charity. In that same year, 89 percent of Americans contributed to charity. More women (84%) than men (79%) believed they should give to charity. More persons under 30 years of age (83%) and over 65 years of age (87%) than any other group agreed that people ought to give as much as they can to charity; however, the highest proportion of givers were persons between 50 and 64 years of age (92%). Although the proportion of people who believed that persons ought to give what they can to charity was not highly related to income, the proportion of people who gave was influenced by income. Seventy percent of persons with household income below $10,000 contributed to charity in 1984 compared with 99 percent of those with household incomes of $50,000.[23]

Funding - Foundation Giving

Gifts to foundations rose 68% from 1978-1983. The number of foundations decreased from 22,225 in 1979 to 21,967 in 1981, which was attributable to 1969 legislation increasing regulations and controlling taxation of private foundations. However, the law has been liberalized since 1969 and from 1981 to 1983 the number of foundations increased by 10.4 percent, the first major growth since 1979.[24]

Foundation funding patterns have varied slightly over the years. In 1980 the highest percentage of foundation giving went to health related activities (25.1%) followed closely by grants to welfare programs (24.5%). Next came education (22.4%) followed by a big drop down to cultural activities (13.5%). Science (6.4%), social science (5.7%) and religion (2.4%) received the smallest percentage of foundation grant monies. In 1984 welfare at 27.5 percent swapped places with health at 23.7 percent. Education declined to 17.4 percent while cultural activities remained relatively constant rising only to 14 percent. Science (7.5 percent) and

social science (7.6 percent) rose while religion dropped very slightly to 2.3 percent.[25]

Funding - Corporate Giving

The last study on corporate contributions reported for all U.S. corporations was from the 1977 corporate tax returns as reported to the Internal Revenue Service. At that time there were 2.2 million corporations; and 525,000 of them (23.4%) reported charitable contributions amounting to $1.8 billion.[26]

As a percentage of corporate income before taxes, corporate charitable contributions have increased from 0.84 percent of pretax income in 1955 to 1.61 percent in 1984. Dollar wise, corporate contributions increased from $415 million in 1955 to an estimated $3.8 billion in 1984.[27] Most smaller corporations do not report contributions on their tax forms. Although research has not been done to confirm the extent of the pattern, it is estimated that many thousands of corporations who make contributions report them as business expenses. Thus, total corporate giving is understated.[28]

Corporate giving varies by industry. In 1977, manufacturing industries gave 51.5% of the total corporate contributions; finance, insurance and real estate companies gave 15%; wholesale retail trade companies gave 16%. A survey conducted in 1983 by the Conference Board showed that manufacturing companies generally gave the largest proportion of their total contributions to education (43%) and health (26%), they gave smaller percentages to civic and community activities (14%) and to arts and culture (11%). In contrast, most of the contributions from non-manufacturing companies went to health (37%), education (26%), civic and community activities (17%) and arts and culture (14%). Large sized companies

39

gave a higher proportion of their contributions to support education (56%) than did smaller companies (47%) and intermediate companies (35%). Intermediate and smaller companies gave a higher proportion of their contributions to health (over 20%) than large companies (10 %). Larger and intermediate size companies gave a larger proportion to arts and culture (more than 15%) than did smaller corporations (12%). Intermediate companies gave a much larger proportion of their contributions to social welfare (18%) than did smaller corporations (10%) or larger corporations (9%).[29]

The Business Committee for the Arts reported that in 1982, companies with annual sales of $50 million and more gave nearly 80% of the business contributions to the arts. Firms in the middle Atlantic states provided the largest percentage of the total support to the arts, 55%. This was followed by North central businesses, 15%. Businesses in the West gave 14%, and businesses in the South, 12%.[30]

The Business Committee for the Arts reported that in 1983, museums received 19% of the total contributions to the arts. This was followed by theatre and cultural centers, 9% each, and symphony orchestras, 8%.[31] Symphony orchestras are the most frequently cited recipients of business arts contributions, but museums take the largest dollar share by donated art funds - 19%.

For the past few years, the Conference Board has surveyed corporations to determine the scope of corporate assistance expenditures given to charitable organizations but not reported as charitable contributions for tax purposes. In 1984, 65 percent of the corporations who responded to these questions reported giving $165 million in cash contributions that they did not report as charitable contributions on their tax forms. Of the 259 companies reporting for 1984,

approximately 27 percent of these corporations reported loaning personnel at an estimated cost of almost $19 million. Of these corporations, 28 percent donated products that were worth $54 million but were not reported as charitable contributions. Other forms of corporate assistance were uses of corporate facilities or services, loans at below market fields, and administrative costs for their contribution function.[32]

Funding - The National Endowment for the Arts

In fiscal 1983, the National Endowment for the Arts reported that they received $142.2 million from Congress. Of this amount, the largest single share ($21 million) was allotted to state agencies. This was followed by music programs ($13.1 million) and museums ($10.1 million). In the National Endowment for the Arts 1984 budget, $24.3 million was allocated for state programs, $15.2 million for music and $12.2 million to museums. Challenge grants were increased from $18.4 million in 1983 to $21.0 million in 1984, while allocations to dance companies remained about the same in both years at $9.0 million.[33]

Frank Hodsoll, National Endowment for the Arts Chairman, stated that arts organizations would benefit from more financial help from the federal government. However, it is unlikely that federal subsidies for the arts will increase dramatically mainly due to the size of the government's budget deficit.

Hodsoll indicated that local support is the crucial factor in the survival of arts organizations. Although the Endowment can help, "the institutions must be very savvy and the local people have to put their backs behind them."

Unfortunately, the government *is* cutting back on direct arts funding allocations. Or is it unfortunate? Federal grants and support can choke local innovation. If the view is taken that the federal government should only do what people cannot do for themselves, then the fact that more and more people *are* volunteering and non-profit organizations are increasing efforts to raise funds through volunteers is satisfying and reassuring.

Amount of State Tax Dollars to Each State Arts Agency

The National Assembly of State Arts Agencies yearly calculates the amount of state tax dollars which are appropriated to the arts agencies of each state. The 1987 results were as follows: Alaska had the highest amount: $4.23 per person, while Idaho allocated the lowest amount of money per person, about 13 cents. Connecticut and Virginia were in the middle of the range: 52.5 and 52 cents spent per person. Below is a list, by state, of legislative appropriations given to state art agencies.

State Arts Agencies Legislative Appropriations Fiscal Years 1986 and 1987

	Per Capita (¢)			Appropriations ($)			Line Items
	Rank	1987	1986	1987	1986	% Change	
Alabama	48	24.1	26.2	$ 969,020	$1,045,000	-7.2	
Alaska	1	420.3	800.2	2,189,800	4,000,800	45.2	
American Samoa	10	133.1	131.7	47,000*	44,500	5.6	
Arizona	40	35.9	33.1	1,144,800	1,010,200	13.3	
Arkansas	35	42.7	35.6	1,006,754	836,226	20.3	
California	32	47.7	46.0	12,589,000	11,793,000	6.7	
Colorado	29	50.8	30.6	1,640,647	971,459	68.8	$ 600,000
Connecticut	27	52.5	46.9	1,666,166	1,479,000	12.6	
Delaware	17	97.1	80.9	603,900	496,000	21.7	
District of Columbia	2	378.3	283.3	2,368,000*	1,765,000	34.1	
Florida	13	111.8	88.9	12,710,386	9,761,077	30.2	$ 6,003,580
Georgia	34	45.0	37.7	2,687,779	2,200,588	22.1	
Guam	6	255.0	275.7	305,468	305,468	0.0	$ 88,660
Hawaii	7	216.5	208.9	2,282,092	2,170,485	5.1	$ 125,000
Idaho	55	13.3	208.9	134,000	131,400	1.9	$ 5,800
Illinois	21	75.9	57.0	8,758,300	6,559,400	33.5	
Indiana	43	33.4	33.3	1,836,923	1,830,576	0.3	
Iowa	42	34.0	18.0	981,590	522,593	87.8	
Kansas	47	24.6	24.5	602,707	596,288	1.0	
Kentucky	26	53.2	42.0	1,983,300	1,564,400	26.7	
Louisiana	50	20.1	27.0	900,000	1,205,431	-25.3	
Maine	36	40.7	36.4	473,503	420,292	12.6	
Maryland	15	108.7	43.9	4,776,096	1,909,382	150.1	$ 2,000,000
Massachusetts	4	313.7	282.5	18,265,924	16,379,066	11.5	
Michigan	11	125.5	113.4	11,404,000	10,291,500	10.8	$ 2,549,300
Minnesota	22	65.7	60.1	2,756,083	2,502,961	10.0	$ 889,100
Mississippi	54	15.8	17.9	411,986	465,837	-11.5	
Missouri	18	87.6	137.9	4,403,292	6,904,051	-36.2	
Montana	14	109.2	78.8	901,745	649,068	ˉ38.9	$ 37,625
Nebraska	39	36.5	36.3	585,891	582,749	0.5	
Nevada	51	19.1	19.1	178,642	174,270	2.5	
New Hampshire	45	32.6	33.1	325,500	323,000	0.7	
New Jersey	9	177.9	138.3	13,453,000	10,391,000	29.4	$ 750,000
New Mexico	31	48.2	50.1	698,800	713,500	-2.0	
New York	5	273.2	249.3	48,590,702	44,218,900	9.8	
North Carolina	24	64.8	63.8	4,050,637	3,936,067	2.9	
North Dakota	41	34.8	34.7	238,268	238,268	0.0	
Northern Marianas	8	215.1	141.2	40,000*	25,000	60.0	
Ohio	20	84.2	69.7	9,050,963	7,493,265	20.7	
Oklahoma	33	46.5	55.2	1,535,253	1,821,462	-15.7	
Oregon	52	18.4	18.2	494,421	487,048	1.5	
Pennsylvania	23	65.6	56.5	7,780,000	6,724,000	15.7	
Puerto Rico	3	322.2	238.6	10,535,600	7,780,600	34.9	$ 2,291,400
Rhode Island	25	62.0	46.2	599,854	444,357	34.9	$ 183,281
South Carolina	19	85.7	77.4	2,869,596	2,555,563	12.2	$ 250,000
South Dakota	37	40.5	40.2	286,873	283,912	1.0	
Tennessee	46	29.0	76.7	1,382,500	3,615,800	-61.7***	$ 463,000
Texas	53	18.2	30.3	2,983,955	4,846,084	-38.4	
Utah	16	100.1	94.9	1,646,000	1,568,200	4.9	
Vermont	30	49.5	45.8	264,900	242,902	9.0	
Virgin Islands	**	**	102.4	**	103,936	**	
Virginia	28	52.2	34.6	2,979,540	1,947,865	52.9	
Washington	38	38.5	43.2	1,697,395	1,879,419	-9.6	
West Virginia	12	115.8	108.5	2,241,793	2,117,238	5.8	$ 716,314
Wisconsin	49	24.1	24.2	1,148,600	1,151,500	-0.2	
Wyoming	44	33.2	28.3	169,275	144,605	17.0	
TOTAL		90.7		$216,627,219	$195,621,588	10.7%	

* Pending
** Not available
***Due to one-time gift to symphonies in FY86.
Source: National Assembly of State Art Agencies

Source: *Giving U.S.A.*, 1986 Annual Report, pg. 106.

Of the top ten states and territories, in terms of per capita giving, half of them are located outside the continental U.S. This may reflect a growing attitude of arts appreciation in these rapidly developing areas. Appreciation of the arts is a

concept most often found in developed nations, so this may also indicate the "umbrella effect" of the continental U.S. as encouraging these states and territories toward a more developed appreciation of cultural expression.

The Challenge

Recognition and appreciation for the arts and the contribution the arts have made to a way of life have been measured through both the Ames and Harris studies. The role of the arts was established -- it was positive -- and the arts were needed. Beginning with the 1980s, more had to be done with less. In 1965 there were only 22 theatres, 58 orchestras, 27 opera companies and 37 dance companies eligible for National Endowment for the arts support. In 1985, 389 theatres, 192 orchestras, 102 opera companies and 213 dance companies applied for Endowment support and many more were eligible. Volunteers were needed as never before.

Contributions to the arts and humanities in 1986 accounted for 6.7% of the total contributions to all philanthropy in the U.S. This compared with 6.4% in 1985. The American Association of Fund Raising Counsel reported that in 1986 all categories of donors increased the amount they contributed to arts and humanities. In addition, the country's largest coalition of charitable groups have recently announced a five-year, $2.5 million media campaign to persuade Americans to double the amount of money and time they donate. According to Independent Sector, if the goal is met, total giving in the country would balloon to $159.6 billion by 1991 and six of every 10 adults would be volunteering time for charitable services. The campaign will suggest that Americans become "fivers" --donating five percent of their income and volunteering five percent of their time.

REFERENCES

Chapter One

[1] Ames, Amyas, National Committee for Cultural Resources Report; Americans and the Arts, August, 1975, Associated Counsel for the Arts, pg. 12.

[2] *Americans and the Arts: A Survey Of The Attitudes Toward And Participation In The Arts and Culture Of The United States Public*, New York, New York: National Research Center for the Arts, 166 pages, 1975.

[3] *Ibid.*

[4] *Ibid.*

[5] Brisken, Larry, *Arts and the States.* A Report of the Arts Task Force, National Conference of State Legislatures, 1981, pg. 59.

[6] *Americans and the Arts: A Survey Of The Attitudes Toward And Participation In The Arts and Culture Of The United States Public*, New York, New York: National Research Center for the Arts, 166 pages, 1975.

[7] *Ibid.*

[8] *Ibid.*

[9] *Ibid.*

[10] *Ibid.*

[11] *Ibid.*

[12] *Giving USA: 1984 Annual Report*, American Association of Fund Raising Counsel, Inc., pg. 97.

[13] *Giving USA: Estimates of Philanthropic Giving in 1986 and the Trends They Show*, A publication of the American Association of Fund Raising Counsel Trust for Philanthropy, 1987, pg. 58.

[14] *Ibid.*

[15] Hodgkinson, V.A., and M.S. Weitzman, *Dimensions of the Independent Sector: A Statistical Profile*, Independent Sector, Second Edition, 1986, pg. 3.

[16] *Ibid*, pg. 79.

[17] *Ibid.*

[18] *Ibid*, pp. 72-81.

[19] *Giving USA: Estimates of Philanthropic Giving in 1986 and the Trends They Show*, A publication of the American Association of Fund Raising Counsel Trust for Philanthropy, 1987, pp.11-18.

[20] *Ibid*, pg. 11.

[21] *Ibid*, pg. 100.

[22] Hodgkinson, V.A., and M.S. Weitzman, *Dimensions of the Independent Sector: A Statistical Profile*, Independent Sector, Second Edition, 1986, pg. 81.

[23] *Ibid.,* pg. 68.

[24] *Ibid.*, pg. 82.

[25] *Ibid.*, pg. 90.

[26] *Ibid.*, pg. 96.

[27] *Ibid.*, pg. 93.

[28] *Ibid.*, pg. 96.

[29] *Ibid.*, pg. 99.

[30] *Giving USA: 1984 Annual Report*, American Association of Fund Raising Counsel, Inc., pg. 91.

[31] *Ibid.*, pg. 90.

[32] Hodgkinson, V.A., and M.S. Weitzman, *Dimensions of the Independent Sector: A Statistical Profile*, Independent Sector, Second Edition, 1986, pg. 95.

[33] *Giving USA: 1984 Annual Report*, American Association of Fund Raising Counsel, Inc., pg. 94.

CHAPTER TWO

PROFILES OF VOLUNTEERS FOR THE ARTS

In order to fully appreciate the accomplishments of those who volunteer and achieve outcomes for the arts, we felt we needed to personally communicate with arts volunteers through written questionnaires, personal interviews and requests for personal statements pertaining to their volunteering philosophy. Our efforts to locate national valid extensive research information failed, therefore information profiling various aspects of volunteers for the arts had to be generated.

We were interested not only in statistical information, but on such basic issues as:

Do more women than men volunteer for the arts?

Do people volunteer more as they advance in age?

What are the differing (and same) reasons for men and women volunteering?

Do more highly educated people give more hours in volunteer work?

Do more highly educated people hold higher positions in their volunteer roles?

Does the level of income change the reasons for volunteering?

Does the level of income affect the number of hours one volunteers?

In short, why *do* people volunteer for the arts?

The first portion of our study began by gathering information on major organizations for the arts throughout the United States and exploring their special fund raising events. From this compilation of activities which consisted of auctions, horse races, balls, dinners, fairs, luncheons, etc., the range of events, frequency of

activity and monies both grossed and netted were noted. As an aside, one major problem not anticipated was the difficulty in finding information. Even though various groups such as state arts commissions, national associations, and the President's Task Force on Private Sector Initiatives were used, the search was long. Informative, descriptive summary reports of fund raisers were difficult to locate and yet would be helpful to all volunteers if these were readily available. Information such as number of volunteers used, number of attendees, organizations plan used and monies earned -- gross, net, amount per volunteer --plus evaluation techniques would all be helpful to other fund raising groups. Energy is wasted and time is spent to find management systems that often duplicate those used by other organizations and committees doing the same fund raiser in another city. It was often found that only the event's main chairperson had a complete view of the total event. Definitely needed is a single national registry for arts fund raising organizations. This registry could then disseminate profiles on successful events, develop summaries of requirements for projects, and could help identify persons with special experiences or expertise. By having such a national registry, much frustration and time for reinvention of the wheel could be saved and energy so vital to projects could be used for evaluation of the specific projects in order to achieve greater successes through increased earned revenue.

The second portion of our study for evaluating the outcomes of volunteers was to actually question, through written survey, the activity, the motivation, and time involvement of those who were actively participating in an arts support project. From our national search to locate unique or outstanding arts support organizations throughout the United States, we started a list of those that used *large numbers* of unpaid volunteers, kept paid staff to *minimum levels* and *did not depend on government grant monies*. The search in itself became time consuming as little

qualitative information about successful events appears to be exchanged through efficient channels. Tracking these organizations took on a scenario much like a detective tracking a suspected culprit!

Each area of the country has many arts activities, but those activities defined as using large numbers of volunteers and being unique were difficult to locate. Repetition of previously tried events appears to be the norm. Those using large numbers of volunteers were important to us as we hoped to have these volunteers respond to our questionnaire to pull together our profile.

Our written questionnaires went to volunteers within the arts organizations and agencies described in Chapter three. The questions sent and answers returned are certainly not scientific -- we did not generate statistics, it does not qualify as scholarly research, nor do we have figures on a percent response -- our goal was to simply to learn a little more about America's volunteers for the arts.

The questionnaire we sent questioned the background of volunteers with regard to the following categories: sex, age, education, income and position held in their volunteer organization. In addition, responses concerning reasons for volunteering, hours donated to volunteer activity per month, years volunteered, activity, participation in other volunteer activity outside of the arts and spouse involvement were examined. We specifically asked questions regarding the following:

1) *Sex*: Sex and its relation to one's reason for volunteering, hours donated per month, participation in other volunteer activity outside the arts, age and spouse involvement.

2) *Age*: Age and its relation to years of volunteer activity, reasons for volunteering, hours donated per month and position held within their arts organization.

3) *Education*: Education and its relation to reason for volunteering and hours donated per month.

4) *Income*: Income and its relation to reason for volunteering, spouse involvement, and hours donated per month.

5) *Position held in volunteer organizations:* Position and its relation to hours donated per month, years of volunteer activity, participation in other volunteer activity outside the arts, reason for volunteering, age, education and spouse involvement.

Who Are We? What Are We Like?

We all know that both men and women volunteer their time but there are differences in the manner in which women and men volunteer and their reasons for volunteering. For example, while both men and women state that the number one reasons for their arts volunteerism is their belief in the arts as a national resource, their second and third reasons are highly contrasted. For women, the ability to meet people is second followed by their desire to help others. Interestingly, men say that their second compelling reason for volunteering is their need to perform a patriotic and civic duty within their community. Their third most common reason for volunteering is the psychological rewards obtained from volunteering as a contrast to the rewards from their own careers.

Not surprisingly, more women hold committee chair positions (e.g., Reservations Chairman, Volunteer Chairman) than men while more men hold board positions. Men have larger networks and less personal time. Because of this, women donate more time per month to volunteerism than males but not by a wide margin. The majority of people volunteer 10-20 hours per month although a small percentage of women volunteer over 120 hours per month! (Remember these persons probably fall within our earlier discussion about the Professional Volunteer.)*

Because most people volunteer for more than one organization, we thought it would be interesting to see what other areas appeal to the arts volunteer. So, we asked about their other areas of interest. Both men and women state that civic activities (e.g., preservation, Junior League, Red Cross, City Council) are next in importance to them. While women have more involvement in their church and men are more involved with business related activities (Rotary, Chamber of Commerce), both volunteer frequently for medical causes and educational projects. Men gravitate toward higher education (post secondary) while women are involved in preschool, elementary and secondary levels.

* These numbers contrast with those in Chapter One for two reasons: 1) Chapter One gives hours donated for all areas of volunteerism whereas these numbers are for the arts only; 2) Chapter One figures include both formal and informal volunteering. Because these questionnaires were sent directly to not-for-profit arts organizations and their volunteers, the numbers reflect formal volunteering which tends to be more time consuming.

53

As an aside, it is somewhat interesting to note that arts volunteers tend not to volunteer in areas of personal hobbies (runners working at a local 10K, for example) nor in medical fields that work with the aged.

In addition, for women who volunteer within the arts, slightly over half of their spouses also volunteer within the arts. The number increases for male volunteers where it was found that over 87% of their wives donated time to the arts.

We took a look at the differences in volunteers based on their position within an organization. We divided volunteers into one of four groups: Executive Board Member, Board Member, Committee Chairman, and Committee Member. As expected, volunteers responded that Executive Board Members donate the most hours per month. Executive Board Members average over 100 hours per month, while Board Members drop to around 24 hours per month. Committee Chairmen give an average of 16 hours per month while Committee Members donate 8 hours. Most Executive Board Members (92%) have volunteered over 7 years with 31% giving their time for over 20 years.

All categories of volunteers were donating time outside the arts field with Executive Board Members leading by working 2.3 other organizations. This is followed by Committee Chairpersons working in 2.15 other areas, Board Members in 1.95 other areas, and Committee Members volunteering in 1.6 other organizations.

Volunteers for the arts tend to be highly educated. Nearly 77% of Executive Board Members have a college degree and 15% of this group have graduate degrees. Three-fourths of Board Members have college degrees with over 36%

holding a graduate degree. Eighty-two percent of Committee Chairs held college degrees with nearly 38% having earned a graduate degree and seventy-five percent of Committee Members have graduated from college with over 25% holding a graduate degree.

In our questionnaire to arts volunteers, the single largest group of volunteers (27.6%) was found to be between the ages of 31-35 years, and the smallest category was ages 65 and older (1.97%). However, no matter what the age group (18-65) people volunteer for the arts *because they BELIEVE in the arts*. The second most popular reason was the opportunity to meet others followed closely by the desire to help others.

Not surprisingly, younger volunteers donate fewer hours per month than older age groups who supposedly have more available time. Also, in speaking of time, people with college and graduate degrees volunteer fewer hours per month than those less educated. Presumably, when more highly educated your career demands more of your time.

Of the people who responded to our questionnaire, nearly 23% earn between $76,000 - $100,000. Of the remaining 77%, over half earn under $25,000. Regardless of income level, again, the single most repetitive reason for volunteering for the arts is the personal belief in the importance of the arts. Those persons earning less than $25,000 per year in annual salary also feel that meeting other people through volunteer activity is an important reason whereas respondents in other income categories list no other reason so dominantly as their belief in the arts.

At the $76,000 - $100,000 income level, volunteering as a viable method of receiving recognition is listed as the *least* important reason for volunteering. The respondents in the $200,000+ category also state that their desire to help others and their patriotic duty are important reasons to volunteer.

Volunteers earning over $76,000 (incomes combined) consistently have spouses who volunteer in the arts whereas 80% of the spouses do not volunteer in those families earning less than $25,000. Those earning between $100,000 - $200,000 and those not employed donate the most hours to their organization averaging a little over 16 hours *per week*. The persons not employed category would be composed of students, children between the ages of 12-21, and financially independent adults.

Hopefully, this has been enlightening to you and you found yourself comparing your volunteer habits with those listed above. Admittedly, this is simply a thumbnail sketch of the typical arts volunteer, for we all realize that each volunteer is an individual and therefore unique and what motivates each and every one of us will be different based on our lifestyles, exposures and experiences. That leads us to a more in depth look at why we all feel this desire to give of ourselves, to contribute, and to leave behind something better than was there before.

Why Volunteer At All?

We know people volunteer. All descriptions of people volunteer But why? What can each person gain?

"Few aspects of American society are more characteristically, more famously American than the nation's array of voluntary organizations and the support of both

time and money given to them by its citizens. Our country has been decisively different in this regard from the beginning. As the nation was settled and moved westward, communities existed before governments developed to care for public needs. The result was that voluntary collaborative activities were formed to provide basic social services. This practice of attending to community needs outside of government has profoundly shaped American society and its institutional framework. While in most other countries major social institutions are state run and state funded, in the United States many of those same organizations are privately controlled and voluntarily supported."[1]

The personal commitment to volunteering in general and certainly for the arts has been credited to be in line with the American way of making things happen. America was founded and developed by immigrants who had a pioneering spirit, people who came to find a better life. They achieved improvement through finding opportunity and giving of hard work. They moved West to settle the frontier knowing that every comfort had to be developed, that no one would have the time or energy to provide for the luxuries of life. Yet part of knowing the hardships in pioneering brought an attitude of respect for others who left safety, security and physical comfort to develop a beautiful country and to develop themselves. American pioneers have always helped each other in time of need or when the job was too large for one person or for one family unit.

The pioneering spirit did not and even today does not want control or enforcement by government when not necessary. Giving help to others and cooperating were codes for survival, partially because of not knowing who would need help next.

Every human has needs that must be met for survival, yet other desirable needs add to the quality of one's life. The basic needs of food for the body and shelter from the elements must be satisfied in order to free the mind to concentrate on needs beyond those of mere survival.

Early in the 1950's, Abraham Maslow formulated his hierarchy of needs while studying the basic elements required for individual existence. The Maslow Hierarchy placed each need on a priority triangular ladder arrangement with the most effort and focus placed at the lower level while the most abstract was at the highest level. This theory regarded the individual as a constant worker toward mastery of his own environment. Basically the Maslow theory accepted the individual as one who is striving to master all needs in the hierarchy. If those needs of food, water, and shelter are met, then the other needs can be considered. As one need is achieved or is controlled, then another comes into focus. Maslow's hierarchy, however, left out several needs which can also be important--those of manipulation and mastery.[2]

MASLOW'S HIERARCHY OF NEEDS

Aesthetic Needs — Needs that pertain to beauty, order and balance

Knowing & Understanding — Needs which fill one's curiosity, learning

Self - Actualization — Needs one has for feeling she is making progress towards reaching her full potential, whatever that may be; that she is doing what she is best fitted for in terms of skill and ability; the desire to become everything one is capable of becoming

Psychological Needs — Needs that represent one's ego in operation and include such things as status, recognition, prestige, esteem and self-respect; the desire to stand high in the eyes of others

Social, Love Needs — Needs one has to feel she belongs, that she is an accepted member of a group and an integral and important part of the organization to which she belongs; the desire to give and receive affection, status

Security Needs — Need for a predicted and organized environment; physical security is one's desire to be safe from personal harm; economic security is one's desire to reach a reasonable economic level for security about income - thus one wants to avoid both present harm and the threat of future harm

Physiological Needs — Needs of the body for food, water, shelter, clothing, air, sleep, sex, activity, protection; desire toward self-preservation; satisfaction of these needs is necessary for survival

In present times the primary needs of most active individuals are guaranteed either through the result of their own work for pay or by government sponsored subsidy programs. This fulfillment of the basic needs allows most other psychological needs including esteem and admiration from others to be met. Self actualization toward fulfillment of one's potential leads to learning or experimenting. The desire to know and understand then allows attention to be given to beauty, order and balance. That in itself can serve as inspiration for further accomplishment on higher rungs of attainment. The satisfying needs should lead one to a most productive, active yet tranquil, existence.

Maslow's Hierarchy, because of its triangular positioning gave little emphasis at the top in relation to the bottom needs. If the needs were to be considered of equal importance, especially in a society that practices cooperative specialization, then more persons would be likely to concentrate on providing the beauty, order and balance for all the society members. The beauty, order and balance of all needs really becomes the society's culture.

The motivation of the Professional Volunteer and the need to volunteer may be more deeply rooted than society has recognized to date. Needs of the individual have been classified as being either internal -- those necessary for survival -- or external, those which are imposed on the individual by society. Socialization of the individual represents the transference of society's need or the acceptance of society's expectation by the individual so that the person accepts them as his/her own.

Internal Needs

Our Basic Needs

The inborn needs must be met for the individual to survive. These needs are primary and must be met each day, therefore forming a pattern or schedule. Most people meet the primary needs with a minimum of effort, in fact, society has divided the labor required to keep an individual's basic needs met. From almost birth, the individual learns to do something about them. Hunger is uncomfortable; lack of food leads to weakness. Thirst also is intolerable. The need for sleep can be intense, therefore the individual will withdraw from even the most exhilarating activity to refresh the body with prolonged intense rest. Along with hunger, thirst and sleep, there is also the need for temperature regulation. People become well able to control their own comfort by either the addition or withdrawal of layers of fabric or increased or decreased activity.

Childhood is generally accepted to be the period when primary physiological needs are met by a primary care giver rather than by the self. The immediate family members are most often the caretakers of the young. As the individual learns to take care of the primary needs, maturity is reached. The individual with non-impaired intelligence learns to become efficient in meeting the needs of the self and those in his/her care.

Our Secondary Needs

But there appears to be other kinds of needs that motivate and encourage human behavior. Some needs are so common among people that these needs too may really be primary needs, because these needs may be common to all. These are the needs of manipulation, mastery of a skill, exploration, and providing for others.

The satisfaction of these needs may be less able to be clearly categorized because the activity is not so clearly distinctive as in food preparation for the satisfaction of the hunger need. Exploration, manipulation, and mastery appear with such regularity that they do not really appear to be external. If the individual is in good physical condition and not completely involved with meeting the primary needs of the self or dependents, the need to explore, to try, to experiment, to develop is strong.

Until relatively late in time, the man was the explorer. The woman was expected by society to be the caretaker of both the young and the aged. Yet all through history there have been women who were explorers. These women explorers had two commonalities: First, the women were able to have their own primary psychological and physiological needs well met; secondly, the women were not the primary caretakers of others. Many women today give their energy and talents to the realization of dreams for the arts. Women benefactors in almost every city have made changes that would not otherwise come about.

The intelligent individual has a certain fascination for manipulation; there is seldom only one way to do something. Yet this difference is most interesting because the techniques used can have opposite traits from those of another group. However, the end accomplishment is essentially the same. Note the popularity of game-playing even among adults. Games are meant to offer opportunity for inventive manipulation that will lead to mastery. But manipulation can also use elements wisely to produce the best possible results such as raising a garden or chairing an event, insuring its success by the best manipulation of controllable variables.

Perhaps every individual needs to feel the pride in mastery of a skill or the mastery leading to an accomplishment few other persons have achieved. Mastery of even a most basic skill gives a feeling of pride, of self-confidence, or well being. Mastery of skills or mastery of a challenge usually follow a pattern of becoming greater or more involved as one level is reached. Thus, the example of the Olympic athlete who dedicates full time to training. Goal setting and attempts to reach goals are common to both the individual and society itself.

Mastery in volunteering is the basic need that is fulfilled when a person knows he or she has the practical and proven knowledge to be able to direct others to successfully complete a project or goal. This need directs people to perform professional services for no financial remuneration. In fact, this need really gives no return other than the pleasure of knowing that this highly specialized skill, perhaps years in the learning or development, is used. By using this skill, the person feels fulfilled.

Another identifiable basic need may be that of providing for others. Some people may have experienced a strong person in their near environment who truly acted as the benevolent benefactor--a person who spent most of their time trying to improve society. Traditionally, family members support and provide for their own members. Often those advancing in age want to provide for society because their own life has been productive and filled with all types of pleasure. Most people want to leave the world a better place; in fact it is important to leave their mark as a memorial.

External Needs

The needs of an individual which society sets or expects are sometimes hard to distinguish from innate basic needs because of society's profound motivation factor. The form these needs take differs from culture to culture, yet the needs must be met for the individual to be an accepted part of society. The external needs shape accepted modes of behavior which undoubtedly create part of the basic status an individual has in society. The way an individual appears to others through dress and grooming practices are mainly set by the society's culture.

Society has many expectations such as being trustworthy, knowledgeable and generous. The acceptance on the part of the individual begins in early childhood when patterns of self-release and modes of behavior are learned. It then continues in late childhood and adolescence with the expectation of the achievement of goals which would provide for a family, making the choice of vocation at which one can succeed, and living a lifestyle of which society approves. Without this approval, society can react in the opposite manner by showing psychological disapproval or outright ostracism.

The individual has many expectations made of him/her by those in the primary family, extended family and the community. Living up to the expectations of all others is indeed difficult. If this is not successfully done, failure can be inferred and can be painful. The ability to excel not only in one part of life but in all life's diverse areas appears to be an attitude and expectation of Western philosophy. Few individuals can excel in all ways, therefore ways comfortable to them that give satisfaction need to be found.

Volunteering to Meet Needs

Participation by volunteering for the arts can be the opportunity for satisfying any one of a number of internal or external needs such as experimentation, exploration and gaining both self definition and self worth. The individual may not realize those needs are being met nor that the needs even exist. A contented individual is the goal, one who has pride in himself and feels he is a worthwhile contributor to society. Two other internal needs are the desire for new experiences and the need for a feeling of adventure. Most lives are lived following long term or established routines that are dictated by the responsibilities which a person has undertaken. Almost everyone has a feeling for adventure. (If human beings did not seek adventure the world--and now outer space--would not be explored as thoroughly as it is!) Yet not all people can devote their whole livelihood to the quest of adventure. By volunteering for projects, one who would not ordinarily partake of adventure can bring some adventure into his life. Working toward goals that bring enjoyment and beauty may form a unique adventure with quite lofty outcomes.

According to a 1983 Junior League Study of 64 national and international voluntary organizations, the most frequently cited reasons for joining the organization were the opportunity to serve others and to improve the quality of life in one's community. Although women's groups were not likely to cite social change or advocacy as reasons to volunteer, their internal need for friendship was cited by half the women's groups as an important factor.

Personal Gains

For the person who volunteers, there are many gains within volunteering which help in meeting an individual's personal needs. The benefits from volunteering include: increased feeling of self-worth, an opportunity to perform work, increased job opportunities, increased identity in the community, and an opportunity to give back to the community in which one is living.

1. *Self Worth*

The first benefit from volunteering is increased self-worth. Volunteering can help one achieve self-fulfillment through the following opportunities it provides: 1) growth through experience; 2) ego-gratification through external recognition; 3) an opportunity to manage; and 4) socializing thus widening one's circle of acquaintances.

(a) The chance to develop and improve skills increases an individual's ability for growth. Volunteering allows one the opportunity to pursue personal goals and delve into areas of personal interest.[3] Volunteering is a learning experience, allowing the individual to have a better understanding of the interaction of his/her city, town, community or group. Volunteering increases growth through awareness of government agencies, special procedures, learning who to contact, who to invite, how to manage a function, how to lead others and how to work as part of a team.

(b) The second aspect of increasing self-worth through volunteering is through external recognition which can provide ego gratification. Everyone may need to be involved in an activity outside the home to receive external recognition. Although cleaning house or ironing may provide personal satisfaction, it does little to attract attention from the community. The lack of perceived dignity in or an appreciation of housework can cause women to become frustrated. Career people, however, receive this external recognition for work done in the work place. Pay becomes the reward. Prestige and respect may increase when one works on a project society values. Although public recognition may not be important to some, many volunteers feel gratification when an audience applauds a ballet, drama or concert that was brought about by their own efforts.

(c) The third manner in which volunteering can increase self-fulfillment is in providing an *opportunity to manage*. Volunteering gives the individual a chance to be a manager without years of training in a subordinate position. This experience is not normally available to the non-employed person. This has been especially true for women. The women's group, NOW, has encouraged the changing of volunteer activities from those which maintained women's dependence and secondary status (bake sales, envelope stuffing and telephone campaigns) to activities which allow women to take a more active participation in the decision making

process. An increasing number of women are now found on administrating boards for such powerful organizations such as United Way. A 1980 survey showed that 21.5% of United Way's governing board were women. United Way of San Francisco reported that between 1971 and 1981, the number of women on the board increased from 19 to 45 percent.[4]

(d) Finally, volunteering can increase self-fulfillment by providing an opportunity to socialize. If one is new in the community, volunteering is a rapid way to meet people. It gives a person the chance to socialize with dynamic, innovative people and to associate with creative individuals who may be from a world quite different from his/her own yet the project gives all a common interest.

2. *Work*

The second benefit from volunteering is that it can be equated with work. Work in American society brings a certain amount of prestige. This impact stems from our country's work ethic brought by the early settlers to the United States. Work brings with it rewards. Any work which allows individuals to use their best talents will assist them in becoming contented. This is a psychological reward that is not always available at a primary job. Work gives a sense of belonging. It makes the individual become a part of the real business of the world and not just a bystander. Work gives a feeling of being wanted and needed. It gives one the freedom to say what needs to be said. Work gives the individual the ability to make changes and to see

the results of these changes. Work gives the opportunity for direct participation.

Work is dignity. Work can be analyzed by the individual to determine the kind of work that is worthwhile, is best liked, and energizes him. Above, when we insert the word *volunteering* for *work* it is easy to see the many internal benefits received by the individual through voluntarism. Most importantly, however, is the conclusion by the individual that the work he is doing is worth doing for others. If something really needs to be done, it is worth someone doing it.[5]

3. *Job Opportunities*

The third benefit from volunteering is that it can increase an exposure to job opportunities. Not only is volunteerism activity now frequently being requested on job applications, but contacts made with prospective employers through volunteer activity provides the volunteer with an inside connection unattainable in any other way. This is especially true for employment with government agencies.

Volunteering produces skills which can be transferred to the commercial workplace such as management skills, public relations and organizational skills. It is a viable method of building a "mentor" network. Although men have been easily able to become or to establish a mentor relationship (i.e., "good ol' boy"), women have tended to act autonomously. Volunteering is now giving women the chance to also increase their contacts. This mentor relationship can

extend into areas beyond volunteering such as commercial and political levels.

4. *Community Identity*

The fourth benefit from volunteering is that it increases community identity. Whether one is new in the community or a native, volunteering gives him additional exposure to his environment. Businessmen often find it necessary to volunteer to become better acquainted and known in their community by both their peers and prospective consumers.

5. *Return to Community*

The fifth benefit from volunteering is that it provides a return to the community. Everyone *takes* from their communities and should be expected to *give* back to them. Volunteering provides a sense of making a contribution to the common good. It is a repayment of benefits everyone receives such as city parks, streets, access to art forms, and educational opportunities. It lets people leave the world a little better place than before they were here. By giving back to the community one feels he really belongs.

B. Societal Gains

There are many ways in which society gains through the volunteer efforts of its citizenry. Volunteering benefits the members of society through 1) increasing the awareness, choice and inquiry of its members; 2) offering the experience of power or control; 3) improving the quality of life for all; 4) organizing valuable holdings such

as museum collections; and 5) providing societal integration of people by varied cultures, experiences or ethnic groups.

1. *Increasing the Awareness, Choice and Inquiry of Its Members*

The benefit of the involvement provided by volunteering produces an awareness of the process of choice by members of society. The diversity of individuals and groups participating in decision-making and goal-setting is increased through voluntarism. Volunteering also maximizes the freedom of choice by allowing people to freely associate or not in groups of their choice.

Volunteering increases the freedom of inquiry of our populace by stimulating research or support on politically or economically sensitive topics of society. Examples would include the collection of art where funded effort may not be popular by other than volunteer sources. It can serve as a catalyst for change and adapting to change in society by other than diffusing these innovations to business or the government sectors.[6]

2. *Increasing the Experience of Power and Control*

The second benefit of volunteering to society is an increased experience of power or control spread among several differing segments in a community. Much has been written about power which is defined here as influence or contact. By volunteering, a person has the opportunity and experience of varying levels of power or control. Volunteering helps in achieving a balanced distribution of power by strengthening volunteer actions and the volunteer sector as a

countervailing force to the government or business sectors. This is important to the arts just as in other segments of society.

3. *Increasing the Quality of Life for All*
 The third benefit is that volunteering improves the quality of life for members of society. It helps promote a greater inclusiveness of the volunteer sector so that all diverse elements of the population can become participants in volunteer action programs or benefit by their advocacy. The action of various volunteer groups and citizen participation within these groups promotes the equitable distribution of opportunities and services of society.

 An increasing number of people from the business world are volunteering. The perspective and leadership provided by these business volunteers benefits both the arts organizations and the business volunteers by making them both look good! Business people on the boards of arts organizations make the community have a stronger, more dynamic appearance which is beneficial to the recruitment of further talent and funding. By serving on boards, business people in turn may add current real life experiences to their general orientation.

4. *Increasing Valuable Holdings*
 The fourth benefit is that volunteering may also increase valuable holdings via increased fund raising efforts or personal solicitation. This includes such items as art in art museums, artists in a symphony, or sets in a theatre. It allows many more persons to experience the

acquisition, thus bringing enrichment. The organizing of collections often falls to volunteers. Organization into manageable collections can make pieces even more valuable.

5. *Increasing Societal Integration of People of Varied Cultures, Experiences, or Ethnic Groups*

The fifth benefit is that volunteering contributes to societal integration and creates a shared sense of trust in our society. Recently, the emphasis of volunteering has had a movement toward advocacy. For instance, the Junior League may not actually manage a function but instead direct "seed money" to get the project started. The work is not actually done by Junior League members but the money award assures that those closest to the project can follow it through.

REFERENCES

Chapter Two

1 *Commission on Private Philanthropy and Public Giving,* 1975.

2 Maslow, Abraham, *Motivation and Personality*, Harper, 1954.

3 Klein, Julia M. "Volunteerism" *Working Woman,* 7:67-70, June 1982.

4 *Ibid.*

5 Wexler, Jacqueline, President of Academic Consulting Association in New York City.

6 Smith, David Horton, *Voluntary Sector Policy Research Need,* Washington, D.C., January 1982.

CHAPTER THREE

SUCCESSFUL VOLUNTEERS AND ENDEAVORS

In Chapter two we mentioned that we gathered some of our volunteer information from arts organizations across the United States. It is important that we profile these organizations here in Chapter three so that readers of this book have a better understanding of the source of our volunteer information.

The largest number of fund raisers are done in areas where there exist large numbers of charitable, not-for-profit organizations. This is obvious, so, of course, these areas would be both the East coast (primarily New York, Boston, Philadelphia, Washington, D.C.) and the West coast (California generally and Los Angeles specifically). There are *many* worthy and mentionable fund raising endeavors that rely on large volunteer networks, but our problem in these areas was in finding that *unique* and different endeavor that would also provide interesting descriptive reading. Admittedly, fancy dress Balls on the East coast are outstanding, the auctions are incredible and raise large sums of money, and the designer showhouses in old historic mansions are beautiful. These are usually well reported in newspapers and magazines. But these events are also conducted in other parts of the country, making them not that extraordinary and unique, even though extremely important and worthwhile.

In addition, the emphasis of this book is on volunteerism nationally. This includes volunteerism in small towns like Bemidji, Minnesota, Hoylton, Pennsylvania and Willipaw, Washington. We want everyone to feel a part of this spirit of volunteerism and our feeling is that reading about projects in less well

known cities might pull us together, might unify us. This may be better than reading, once again, about how fantastic everything is in New York City or Orange County in California.

Finally, the Professional Volunteer, that person we identified as the person who has seen event after event and worked on project after project, may find the following write-ups "old hat". But, it is the hope that the volunteer who is searching for ideas, stimuli, the planting of a seed will find something written here to assist them in their particular endeavor.

The Ball: Profile of Most Popular Activity Supported by Volunteers

SHALL WE DANCE? From the statistics available, volunteers probably should! The Ball appears to be the most common and widely held volunteer supported activity and interest in the Ball is as old as the United States itself.

In order to review what events were being held, a summary chart was developed for national major arts organizations. The events quickly fell into one of thirty-two categories plus a miscellaneous division. By far, the most common events were the Ball, the fashion show, and the dinner and auction, with the Ball being by far the most popular.

Interest in dancing, translated into the "Ball", continues even though the origins in the "Ball" are very old and forms of dancing even older. Elements of ancient ritualistic and courtship practices are contained in many of the folk dances of America and Europe. The "folk" concept embodies the ideas that dance forms have evolved over long periods of time as social practices, and that dance forms

have developed in the process of handing on the patterns which make up those forms from one generation to another...[1]

The early medieval dances of Europe included processions of couples and groups of singing dancers. This formed the Carole. For 200 years, starting during the mid-14th century, the "dance basse" endured. This dance consisted of a limited number of steps of ceremonial gliding movements. There were no professional teachers before the 15th century -- mimes and jugglers were the teachers. Court and folk dances were separated when the dance masters appeared and dancing techniques were developed during the 15th century. The dance remained largely spontaneous, however, movement was restricted by the increasingly voluminous clothes of women and men of nobility. Often dances became little more than an excuse to display finery.

During the 16th century, a more varied and liberal outlook brought a greater scope of self-expression in entertainment. Dance became a way for a man to display his ability and skill. Dances of the 16th century included the Galliard, Povance, Olta, Courante and the Allemande. During the 17th century the increased skill needed for the execution of dances caused the social dances to leave the hall and go on the stage. This was the basis of ballet. As clothing grew simpler, dancing styles were transformed to country dancing including square dancing. The Minuet also developed in this era.

During the 17th century in Puritan New England, the rule of Calvanism prohibited any part of playacting including drama, certain forms of music and dance. Mixed dancing between men and women, dancing in taverns, Maypole dancing

(seen as an expression of Paganism) and dancing accompanied by feasting and drinking were all forbidden by the Puritans.[2]

Although Puritans condemned "mixt or promiscuous dancin", they indicated that dance could be used as a means of teaching "due payse and composure of body". The Puritan ministers indicated that a parent wishing to have his children learn dancing should send them "to a grave person who will teach them decency of behavior, and each sex by themselves.[3]

In the 18th century, the Reverend John Catlan, a leading minister in Boston and New England, made the same distinctions regarding dance as the church fathers during the Dark and Middle Ages in Europe. Catlan said that he saw two sorts of dancing: religious and civil. He condemned only lascivious dancing with amorous gestures and wanton dalliances, especially after the feasts.

However, 17th century court records, especially in New England, indicate that others were less liberal than Catlan regarding dance. The records mention severe punishment for dancing in taverns, mixed dancing and similar offenses. Despite punishment, North Colony settlers continued to dance.

John Playford's "Dancing Master", a published English work, was used as a guide for the dances taught. These country dances did not involve "couple dancing", but instead, had the men and women dancing together in formations. These dances were accepted by the ministers as they were desired by the influential people of the community and taught good manners.

The attitude toward dance was less restrictive in other colonies than in New England. The Dutch settlers in New Amsterdam danced on special holidays and at public fairs. In Virginia, where settlers were of a higher social class, dancing was one of the forms of amusement indulged in by the settlers. Dancing was seen, in Virginia, as an accomplishment proper for a gentleman and to dance gracefully was a commendable quality for a lady.

In the 18th century a growing number of dancing teachers were found in both the North and South Colonies. Many of these masters advertised to the public and travelled from town to town as did the preachers, doctors, lawyers, and peddlers. Social dancing had become accepted as a means of education and a form of recreation.

Toward the end of the 18th century an increasing number of balls and assemblies were held. Dances performed by the Colonists included both the jig and country dances, and the Minuet, Rigadoon and Gavotte (the latter three all found in Rameau's text). Dance had become an important part of the Colonist's social life.

The 18th century in Europe witnessed the houses of the nobility becoming centers for social activity including dancing. Professional dance masters invented new dances and added to old ones. In the 19th century, dancing continued to flourish and was popular and widely accepted throughout the United States. The religious objections to dance had mostly diminished. Dancing varied, ranging from the formal precision found in the cities, to less formal jigs at country fairs in the frontier. In 1840, eastern European countries, under foreign rule, had a great revival of national feeling while western Europe felt great sympathy for these countries. This may have led to the popularity of the Polka, a Bohemian dance.

New forms of dancing such as the Waltz and Polka began to emerge in the 1830's. Although ministers preached against this closed couple position, these new dances won their way into society.

In the United States, the early 20th century brought such dances as the Foxtrot, Charleston, Jitterbug and the Big Apple. In England, a popular profession was the teaching of dancing with schools springing up around the country. In 1950, the International Council of Ballroom Dancing was established.

After World War II, the popular competitive dances were the Foxtrot, Tango, Viennese Waltz, English Waltz and the Quickstep. Young people expressed themselves dancing the Cha-Cha and the Twist.

Establishment of the Ball

As early as 1716, in the form of social gatherings and masquerades, opera balls were established and supported by the rising aristocracy. The female dancers themselves became mistresses of the influential men of the government, while the opera became an important national treasure to show to any foreign embassy.

Dancing styles varied among social classes. The upper social classes had formal cotillions, assemblies and public balls while the lower classes had the less respectable dance halls and beer gardens.

Toward the end of the 19th century, there were huge society balls for those who had wealth and prestige in the major society resorts such as New York, Philadelphia, and Chicago. Dancing was a universal pastime for the upper and

middle classes. Annual balls were given by trade, professional and fraternal organizations.

Balls are now held in every part of the United States and all around the world. Balls are as varied as the people who attend -- large or small, colorful or sombre, traditional or avante garde!

America's Oldest Ball -- The Philadelphia Assembly

America's oldest annual dance, the Philadelphia Assembly Ball, was started over 200 years ago in 1748. The Ball first originated in the United States to pass the long winter evenings of Philadelphia when there was little other activity.[4]

The Philadelphia Ball is not a presentation ball nor a benefit, but is the most exclusive dance of Philadelphia's social season. About 2,000 people attend; most all are descendants of those attending the party of 1748. No celebrities or politicians attend and the press is banned from the party. The Philadelphia Assembly Ball is one of the last main line events held in Philadelphia and brings together the city's wealthy and powerful families.

The Charity Ball

The Charity Ball remains an effective generator of funds for all types of causes including medical research and arts organizations. About one-third of the local American Cancer Society's operating expenses (nearly $400,000) is raised by the Washington, D.C. Cancer Ball. In Denver, the Carousel Ball raises consistently over $1 million each year for diabetes research; it raised 2.7 million dollars in 1984.[5]

In order to insure that people who attend the balls are having a memorable experience, hosts of balls must be truly imaginitive. For instance, at the Bob Hope Classic Ball in Palm Springs, the party room has been decorated like a sheikh's tent and guests greeted by a Hindu dancer aboard an elephant.

The Ball is very much alive and doing well to raise needed monies for arts organizations. Today's ball may be more of a star-studded entertainment extravaganza, however the event seems to be extremely popular by a wide range of organizations and adaptable to any geographic locale.

One quote from a Professional Volunteer said "...satisfying to have a wonderful time at an Opera Ball and to know at the same time you are benefitting an artist or an arts organization." And Barbara Kerrick, Oklahoma City, another Professional Volunteer, wrote "Long Live the Arts." It should be added, "Long Live the Ball," as well!

PONCHO

An organization that raises large amounts of money each year through an annual auction yet offers volunteers all levels and opportunities for personal gain is the PONCHO organization, Seattle, Washington. PONCHO (Patrons of Northwest Civic, Cultural and Charitable Organizations) uses a one night event to raise the monies it distributes each year, yet it uses almost exclusively volunteers to mount the ambitious event.

History

To those living in the Northwest, especially Seattle, PONCHO is so familiar that we can almost recite its twenty-six year history verbatim. PONCHO is both an annual auction (an extravaganza would be more descriptive) and a political entity. PONCHO was founded by three Seattle arts patrons in 1962 to help cover the deficit incurred by the Seattle Opera's World's Fair engagement of Aida. With the overwhelming fun and success of its first year (they raised $165,000 in 1963), the annual PONCHO auction has become a tradition. Today Seattlites respond to the noun "PONCHO" with the world "auction". The biggest difference today from 26 years ago, however, is that PONCHO has become a virtual institution in the city. PONCHO itself wields clout. Its board members are sought for other Northwest fund raising endeavors. PONCHO is both nationally and internationally known. It stands as a model among successful fund raising ventures and has spawned a host of imitators here and abroad. One of PONCHO's premier auctioneers attends Canberra, Australia's CAPO (Capital Arts Patron's Organization), the latest PONCHO duplicate, to aid in its organization and annual auction. PONCHO has organized a written record of its illustrious history which is in the process of being printed. Its records have been accepted to become a part of the University of

Washington archives and the transfer of its 26 years of information will begin in 1989.

Selection Justification

PONCHO meets both of our criteria in terms of being a unique organization and displaying good usage of its volunteer network. PONCHO is unique in that it raises over a million dollars in one evening. In its 26 years, PONCHO has netted over $8,400,000 which has entirely been distributed to arts organizations in the Seattle area. PONCHO's esteemed position within the arts community has led to the naming of events, buildings and performances after its benefactor (e.g., PONCHO Theater, PONCHO Pops Concert, PONCHO Forum Rehearsal Hall). Finally, PONCHO is so appreciated by the business community that in their 26th year return from donations allowed PONCHO to give away $1,000,000 to the Arts of Seattle, thus setting the accelerated pace for its second quarter century. All of this is unique in that Seattle is a relatively small metropolitan area of 495,900 people.

The second criteria, usage of volunteers, is exemplified by the fact that people *love* to work on PONCHO. Composition of the volunteer network for PONCHO ranges from college students to top level Seattle executives. Past volunteers continue working year after year while new volunteers are recruited in with hearty handshakes and rewards for jobs well done. The magic and fun of PONCHO includes incentives such as cocktail and dinner parties with Seattle's elite in top class restaurants, meetings in new downtown hotels with sumptuous spreads of food, and an awards party where volunteers receive their "Oscars" for outstanding efforts.

Structure

PONCHO consists of a Board of Directors which currently numbers 93 members, which includes active lifetime and founding board members. The President of the Board rotates annually bringing a different personality and a new set of goals to PONCHO each year. Other executive board positions include:

First Vice President

Vice President - Party/Production

Vice President - Procurement

Vice President - Reservations

Secretary

Treasurer

Even though the general format remains the same, the PONCHO Board prides itself on improving, strengthening or trying new facets each year. However, any changes must be integrated within the recognized PONCHO framework.

The Board is assisted by a paid full time staff of 2.5 and approximately 500 volunteers. The average PONCHO volunteer is:

Between 31 and 40 years of age

A college graduate

Has volunteered for the Arts either less than 4 years or over 20 years

Works on PONCHO because of his/her belief in support for the Arts

Earns either under $25,000 annually, or between $75,000 - $100,000

Equally split between male and female

The concentrated effort for PONCHO is done by the Professional Volunteers who work on the auction the entire year. A year round office is maintained where the major planning and meetings of volunteer groups takes place. The paid staff role is to assist and guide the Professional Volunteers, provide

backup support for the Board and Committee Chairmen, do research and formal evaluation, and serve as the central communications conduit for the many activities comprising this auction. Yet the staff does not actually raise the money or make policy. The staff sees that complete records from each year's auction are well organized and available for review by new chairpersons. One of the most useful aspects of the office function has been the emphasis placed on evaluation. By seeking and obtaining written summaries by those who work for PONCHO each year, both minor and major glitches that arise can be eliminated the following year. In fact, one of the major strengths of the PONCHO organization has been its ability to evaluate objectively its performance against the goals set by the Board. By having the foresight to critique the event immediately upon completion, future pitfalls can be avoided. Also, this eliminates volunteers becoming discouraged by recurring obstacles. This serious evaluation gives rise to new enthusiasm because the next year can genuinely be advertised as being better than ever!

Description

The actual PONCHO auction takes place in the Spring, usually April. The Board officially begins meeting in September although the Executive Board, staff, and several committee chairs work through the summer. The first major event in the Fall is the Procurement Kick-Off Party at which time procurement of donations officially begins. The most recent strategy has been to divide into 3 or 4 procurement teams, each with team captains and their own name, and stage a competition between the teams. Procurement holds several incentive parties during the following six months to increase individual quotas. Meanwhile, Party and Production committees begin meeting to discuss new formats, set up procedures, store donations, plan dinner menus, and instigate special entertainment. (Annually, the past President's parade is held complete with marching band.) Some years have

also featured celebrities. Although this may sound like all the details of the average auction, these items to be picked up, stored, delivered and displayed are worth over $1,000,000! During the year, newsletters are sent by the staff to volunteers, businesses and guests to keep everyone informed of how PONCHO's plans are coming along. The extensive mailing list is a great tool by which to thank businesses for donations and pre-publicize large and unusual items. The auction currently is held in one of Seattle's newest and largest hotels. However, for the first 20 years, PONCHO transformed the Seattle Center Exhibition Hall from a bleak empty basement in a large gloomy building into a fantasy world professionally decorated by one of Seattle's largest department store displays.

After the procurement windup, the program begins to take a more final form with captivating descriptions of each of the approximate 1,000 items. Because of the quantity of auctionable items, the PONCHO evening is divided into several auctions. On the actual raised center stage, two auctioneers, who are members of the Board and therefore donate their services, work throughout the evening soliciting higher and higher bids as each item is displayed on a large screen or acted out on stage by professional models and actors. Varied silent and smaller live auctions take place outside the main stage area, and an auction called "Bid-O-Gram" (guests have no idea who is bidding against them and at what price) runs through PONCHO's own computer. All items purchased including sailboats, limousines, mooseheads, rickshaws, and train cabooses, must be removed from the site by noon the following day. Package all that with 1,300 guests, a gourmet dinner including a lavish spread of hors d'oeuvres and 1:00 a.m. snacks, press coverage and parades, and you will find quite a party that does not end until dawn's early light! People love it and come year after year.

Concours d' Elegance

The talents and the energies of the volunteer are unlimited. By observing the many descriptions of the actual volunteer and analyzing the many personal and societal gains volunteering offers, development and refining of volunteering opportunities in the future can bring even larger accomplishments.

A limited amount of formal research has been systematically done in the past. Newly formed organizations recognize the need for this formalized research which will assist them in the development of larger outcomes. In our search, one omission from the descriptions of the planning and execution of fund raising events by not-for-profit organizations was the business-borrowed practice of researching an idea and then the evaluation of performance when it was finished.

The most unique single event that began with extensive research was the Concours d' Elegance held in Louisville, Kentucky.

History

In the 1930s, concours classics (car shows) were the social event of the season. It was an opportunity to show off unique new custom-built horseless carriages and compete with one another for the honor of having the most beautiful vehicle. Only the creme de la creme of society were invited to the early concours and their cars were recognized as the finest or most elegant in the world.

On May 23, 1982, history repeated itself when a "Concours d' Elegance" was held at Churchill Downs in Louisville, Kentucky. The purpose of the event was to

give participants a once-in-a-lifetime adventure into the past. The Concours d' Elegance was the ultimate in antique and classic car shows. The idea for the Concours d' Elegance came about at the International Merle Norman Cosmetics Convention held in Louisville. Due to the Chairman of the Board's great interest in antique and classic cars, a decision was made to hold a Concours d' Elegance with the Merle Norman Corporation sponsoring the event along with the aid of a volunteer group. All proceeds from the Concours d' Elegance would go to the volunteer group for determination of distribution.

The volunteer organization chosen by Merle Norman Cosmetics Company was the Louisville Orchestra Association. The Louisville Orchestra, a regional organization, was a focal point of culture and fine musical entertainment for the people of Louisville. The Association was selected because of its reputation for organizing and holding successful special events.

Selection Justification

The Concours d' Elegance was a unique event as there have only been three concours held in the United States. It was the most successful fund raising event ever sponsored by the Louisville Orchestra Association. The concours was also unique in that it raised a large amount of money from a segment of the community *not ordinarily tapped* by arts groups. It offered something for everyone from a $5 day on the infield at Churchill Downs viewing priceless antiques, a $35 per person champagne brunch, to an elegant $100 per person evening dinner dance and cocktail reception.

However, our major reason for selecting the Concours d' Elegance was its nationally unique formation via an intensive two-year project search by a specially

89

selected committee for the Louisville Symphony. This desire to conduct a new fund raising event is not unique, but nationally, we found no other organization that made a commitment and took the time to study and plan an event new to their area and innovative in the fund raising arena with such success.

The event owed much of its success to the extensive effort put forth not only to research the event but the planning that detailed the many parts. The event was then carefully evaluated with recommendations thoughtfully made.

Structure

Prior to the Concours d' Elegance, the Louisville Orchestra Association established a committee which spent two years researching fund raising projects. The competition for Louisville-donated dollars is phenomenal. Therefore, the association needed to find a fund raising project with an attractive different approach. A Ways and Means Committee met 3 to 4 times a year and investigated past projects. After the decision to hold the Concours was made, the committee researched other concours. This included sending questionnaires to car collectors around the country, and investigating similar concours held at Cleveland and Pebble Beach.

The Orchestra Association committee coordinated all the events for the Concours d' Elegance. Two hundred and fifteen members of the association were involved in the project along with thirty community members. The staff consisted of one association member and five orchestra members.

The Association volunteer was responsible for logistics, ticket sales, publication and promotion, participant's packets, program books (including ads,

layout, design and print), securing trophies and other awards and the Concours parties. All expenses were underwritten by the Sponsor, the Merle Norman Company, except the champagne brunch and the dinner dance which were self-supporting.

The project was initiated October, 1981, and completed May 23, 1982. Committees met twice each month from January, 1982 through mid-April. Most committees met weekly and some daily until the event was held.

Description

The events of the Concours d' Elegance spanned 2 days, Saturday and Sunday, with nostalgia being the theme for the entire weekend. On Saturday evening a cocktail party was held which was attended by the car collectors, the judges, and other invited participants. The cost for attending was $50 per person. The cocktail party was followed by a gourmet dinner dance. This served as entertainment for out-of-town guests and Louisville friends and was an additional fund raiser. The cost of the dinner dance (including the cocktail party) was $100 per person. The Saturday evening festivities were held at the nearby restored Sulbach Hotel in Louisville. The entertainment for the evening was provided by "Stompin in the State", a group of singers, dancers and musicians who recreated a 1940s radio broadcast.

On Sunday morning a continental breakfast was held at Churchill Downs infield for the collectors, judges, and arrangement personnel. It was a breathtaking scene seeing thoroughbreds working out on the track, hot air balloons swaying in the warm breeze and sixty of the most beautiful antique and classic cars in the world being driven onto the infield.

At noon, a Grande Prix Championship Brunch was held at the Churchill Downs' sixth floor Clubhouse. This event was by invitation only and was sold out with 400 guests. A fashion show of vintage clothes, jewelry and furs was included at the brunch.

Over 60 antique and classic cars from private collections all over the United States were on display at the Concours d' Elegance. The cars selected for viewing were by invitation. Some of the cars on display were from private collections which had never been seen by the public. Also on display were three cars from the Merle Norman 1932 Classic Beauty Collection including the Twenty Grand Duesenberg (it cost this amount to build the car in 1933), a 1932 Packard Convertible Coupe and a 1932 Stutz 5 passenger sedan.

Competition for awards for the cars was on the basis of perfection of restoration, elegance of design and authenticity. Twelve "Best of Class" awards were presented.

Heading the panel of judges for the event was Phil Hill, the former world-famous Grand Prix driver and current car collector. The panel of judges also included the car world's magazine editors, automobile restorers, designers, and collectors.

Grand Marshall for the Concours d' Elegance was the then Governor John Y. Brown, Jr. and Mrs. Brown who presented the Best of Show Governor's Cup Trophy. Honorary Chairman for the Concours was J.B. Nethercutt, Chairman of the Board of Merle Norman Cosmetics.

Viewing the cars on display Sunday was from 10:00 a.m. - 4:00 p.m., with judging at 2:00 p.m. Approximately 5,000 people attended the event, paying $5 per person and $1 for parking. Along with the cars on display were hot air balloons, a caliope, and brass bands.

Net profit from the Concours d' Elegance totalled $42,500. This included income from tickets, souvenir booths, and food and beverage concessions. Often, the success of an event is not only judged in financial terms, but promotionally through publicity generated and good will achieved. For the Louisville Orchestra, it was indeed a financial success and generated a tremendous amount of national and local publicity for the orchestra itself.

Volunteers for the arts include all people; the people are difficult to quantify but each can use his/her talents and hours in workable ways. Because of this wide diversity, the successful use of all categories of volunteers poses a challenge. The Oklahoma City Arts Festival meets that challenge.

Arts Council of Oklahoma City

The Arts Council of Oklahoma City was established in 1967. It was formed to allow a wide range of programs and services to become available to members of agencies, artists and the community at large. This philosophy of the Arts Council continues today.

In 1982, the Arts Council acquired permanent space in the downtown area of Oklahoma City. This location allowed the Council to play an increasing role in

revitalizing the downtown area. The increased visibility of the Council has led to an increased interest for an established cultural district in Oklahoma City.

Selection Justification

The Arts Council of Oklahoma City was selected to be profiled for two reasons. First, it raises significant amounts of monies; it raised $320,000 from a single event -- Festival of the Arts held in May, 1988. The 1987 Economic Impact Study done on the Festival estimated that this single event contributed $25.8 million into the Oklahoma City economy. Secondly, the Arts Council utilizes a very large number of volunteers -- over 4,000 -- to stage its annual event which is attended by over 800,000 people during the 6 days it runs each year.

Structure

The Arts Council of Oklahoma City is headed by a Board of Directors which consists of the following members:

> Chairman of the Board
>
> President
>
> 2 Vice Presidents
>
> Secretary
>
> Treasurer
>
> 2 Members at Large
>
> 31 additional Board Members

(The maximum number of members is 41).

The goals of the Council are set by the Planning Committee which is appointed from the Board.

The Chairman of the Board appoints a Chairman of the Nominating Committee to name members to the Board. The Nominating Committee Chairman must have a long-term association with the Arts Council and a clear understanding of the organization's needs.

The Board members are representative of the entire metropolitan area. Board members may serve two consecutive three-year terms and then must leave the Board for one year before they are eligible to serve again. Members are selected based on their interest and participation in the arts and cultural community. Two board positions are filled by the Festival co-chairmen from the previous year.

The Arts Council of Oklahoma City has ten salaried staff positions. These include:

> Executive Director
>
> Festivals Director
>
> Projects Director
>
> Audience Development Director
>
> Members Services Director
>
> Public Relations Director
>
> Financial Manager
>
> Festivals and Promotions Assistant
>
> Graphic Artist
>
> Secretary-Receptionist

In addition, 4,000 volunteers work with the Arts Council of Oklahoma City.

Description of Festival

The Spring Festival of the Arts is the major fund raising project of the Arts Council of Oklahoma City. It has been held since 1967 and is the prime source of funds for various education and service programs sponsored by the Arts Council. The festival requires eight months of planning time and has grown from a core of volunteers in 1967 to over 4,000 volunteers who participated in 1988. Approximately 500 Professional Volunteer hours and 41,800 volunteer hours are spent on the festival.

The festival budget is established by the two festival chairmen and the festival director. These three planners set the budget according to what they believe they can have donated in each of the festival areas by businesses in the community, such as a printing company donating the festival tickets. The budget needs are revised each year for each area. For example, every two years the budget allows for the printing of bags for children to carry home the artwork they make at the festival.

The income from the festival is difficult to predict due to the uncertainty of variables such as the weather and the local economy. However, through planning, the financial stability of the festival has increased throughout the years which has allowed the Arts Council to expand and increase its services. The festival net income is used for Arts Council projects in the next fiscal year. The executive director and the budget committee recommend the funds dispersion, then seek the final approval by the entire board.

The net income of the festival in 1988 was $320,000. This income represents over a seven-fold increase from the original 1967 festival income of $46,133.73. In

comparing the 1988 income with the 41,800 volunteer hours which went into the festival, approximately $7.10 was earned per volunteer hour contributed.

Upon completion the festival is evaluated by the volunteers and the staff. The festival's success has been attributed to the committed volunteer force and strong bond between the staff and the volunteers. The festival motto "They couldn't have done it without me", expresses the importance placed on the volunteers by staff personnel.

The future of the Arts Council of Oklahoma City is focused on an increasing role in the cultural development of the downtown Oklahoma City area. For instance, in 1985 the spring Festival of the Arts was the major event for the opening of the downtown park, Myriad Gardens.

The Arts Council believes that it must keep developing new volunteers to keep the organization strong. Volunteers are developed and trained through the Spring Festival. New volunteers may start by working a three-hour shift at the festival and move through the ranks to become an integral part of the event. As the Arts Council expands, many of these festival volunteers can be used to help plan and implement new projects. The festival represents a most successful use of large numbers of volunteers at one time.

Advocating Arts in State Legislatures -- Economic Impact

The economic impact of the arts can be seen by the multiplier effect. Suppose X number of community dollars are generated from every dollar spent by an arts institution, artist or arts' audience or from every state dollar allocated to the arts: this leads to X number of jobs and returns X number dollars in tax revenue to the government. Tourism and the arts have a similar effect since much of the potential economic impact of the arts is from the tourist multiplier. The "I love New York" advertising campaign is an example of a successful effort which connected the arts and tourism. The campaign resulted in tourism growing, theatre attendance increasing and led to an economic impact of $23 million in direct and indirect spending.

However, along with the positive results seen from past studies demonstrating the economic benefits from the arts, there are some drawbacks. First arts' aesthetic value and basis is sometimes depreciated. Second, there can be an overemphasis on the economic impact created by the arts.

Dean Harvey Perloff of the UCLA School of Architecture and Urban Planning wrote there may be a different economic benefit for state arts' support. Perloff suggests that as manufacturing employment numbers decrease, the country will become more dependent on the arts to employ more people. The arts and tourism combined are becoming one of the United State's most important industries.[6]

Perloff's book, *The Arts in the Economic Life of the City*, suggested that the arts can be used economically to develop and revitalize downtown areas and older city neighborhoods and regions. This would increase tourism, the convention trade, other attractions and generally lead to an increased economic impact from the urban communities. Dr. Perloff suggested that the arts meet the central city's poorer populations' income and employment needs which contributes to community cohesiveness. He feels that arts should be tied to various public services such as art therapy and that art be included in urban redevelopment and preservation to maximize arts employment.[7]

The most important economic argument for state arts support is that the arts are a central part of our daily lives. Our lifestyle, from the design in the clothes we wear to the architecture and interior design of our homes, is dependent on the arts.

Minnesota Citizens for the Arts

One of the most outstanding success stories of financial accomplishment for the arts is exemplified by the fourteen-year-old Minnesota Citizens for the Arts arts-advocacy group. This small but efficient group is totally dedicated to supporting the arts through increased funding at the state legislative level. The group, led by a staff of 2 full time positions plus a paid lobbyist, must be strongly motivated and committed to work, often single handedly, to bring about changes that can only take place by precise timing and deft organization. Even though other arts advocacy groups have been formed, the Minnesota Citizens for the Arts has made outstanding strides in obtaining support for the arts, thus its selection for inclusion in our discussion.

History

Of the forty state-wide arts advocacy organizations in the country, Minnesota Citizens for the Arts (MCA) is the oldest. It was founded in 1975 by the Governor's Commission on Arts when the Minnesota commission members determined that earned income was not adequate to fund the needs of the arts organizations. This was due to the tremendously popular interest in the arts by the citizens of Minnesota. MCA is composed of people whose interests are dedicated to the arts and they demonstrate this through the payment of dues and their participation when called upon to help influence their state legislature. The main goal of MCA is to insure adequate continued state support of the arts by state legislative funding through the Minnesota State Arts Board and the eleven regional arts councils. MCA's chief mode of operation and responsibility is lobbying legislators to obtain their vote for funds. Key contact members of the MCA constituents serve as the vital communication link between the community and the legislators. These contact members voice arts related issues directly to their elected officials who can then carry the message to the legislature. Other goals of MCA include restoring arts touring funds within the state, supporting the rights of artists and supporting arts in education.

Selection Justification

In our opinion, MCA is one of the premier state arts advocacy groups in the United States. It is an outstanding volunteer organization for several reasons: First, the use of its 700 members who are constituents has shown to be the best way to convey the message of the need for state support of the arts. The constituents cover the entire state of Minnesota so that all legislators are made aware of this message. The constituents are well informed by newsletters and telephone calls and have basic duties and responsibilities. These duties include educating other members in

the constituent's community and activating letter, telephone or telegram campaigns for support of a particular issue. Second, MCA's governing set-up helps prevent larger arts groups from overpowering smaller groups. A more democratic representation for art fund dispersal is achieved.

Description

MCA has 700 dues-paying members. Approximately 600 of these members are from households while 100 members are related to the arts. A small group of corporations also hold memberships. MCA's membership reflects the population of the state with 50% of the members living in the city and 50% of the members living in rural areas of the state. Members support MCA with a membership fee. Membership costs range from $15 - $500 for an individual membership and $25 - $20,000 for an arts organization membership. Although the state and regional arts boards receive grant money from the state, MCA does not. MCA has no direct programming or workshops.

MCA employs 2 full time members. The staff is responsible for keeping informed on the various bills introduced, handling minor crises in funding, running the office, efficiently filling requests for information, and compiling the newsletter which is published four times a year.

An annual meeting of MCA is held in September. At this time the organization elects 39 members (constituents) to the Board of Trustees. The trustees are all volunteers. They serve a two year term and meet five to six times a year. They represent the thirteen regions of Minnesota which follow the state economic development boundaries.

MCA encourages communication networks throughout the state arts commission. It co-sponsors seminars on information and skills development and provides access to key resource people for consultations with arts organizations. MCA utilizes public service advertising and forms coalitions with other organizations such as the tourist industry.

In the 1986-87 biennium, MCA was one of the major contributors to the Minnesota Arts raising 85-90% of the money donated to the arts in Minnesota from the state. Its advocacy programs brought in $5.5 million during that two year period with the 1988-1989 biennium budget projected to be $6.1 million. Among the states, Minnesota ranks 24th in per capita state appropriated dollars for the arts. MCA has been a leader in the grass roots support to increase state arts funding.[8]

REFERENCES

Chapter Three

1 Encyclopedia Brittanica, Volume 7, Chicago, William Berton, 1966.

2 Kraus, R., *History of the Dance In Art and Education*, New Jersey, Prentice Hall, Inc., p. 101, 1969.

3 *Ibid.*

4 *Los Angeles Times*, December 26, 1983.

5 McManus, Dancing for Disease, *Forbes*, 1983, pg. 132.

6 Brisken, Larry, Arts and the States, A Report of the Arts Task Force, National Conference of State Legislatures, 1981, pg. 57.

7 *Ibid*, pg. 58.

8 National Assembly of State Arts Agencies, Washington, D.C.

CHAPTER FOUR

BASIS OF ORGANIZING A VOLUNTEER PROJECT

How To Organize The Event

There is no doubt that benefits from volunteering are produced by dedicated volunteers. However, to make the most of the time and efforts given, one should review the various possibilities thoughtfully prepared by persons who have successfully experienced and evaluated complete projects. The value of volunteering has been recognized, particularly by Americans, for the past three hundred years. Yet, renewed emphasis has come as public monies began to not be as available and as more organizations sought to qualify for existing funds.

Each case or scenario is different; unique variables are present. However, some suggestions may be given. Projects can be divided into five units. Some of those units may take only a brief time, others may take most of the effort. The units are:

1. *Establishment of Goals and Objectives*

 With the establishment of long term goals, specific objectives and parameters can begin to be set. Goals usually are of a more esoteric nature than objectives. Examples are: The event will increase the operating budget; or, as many people as possible at all age levels will be involved. Goals need to be established carefully for then the parameters of the event will be established as well. If goals are too vague or undefined then the value of their direction will be lost. Goals provide limits. These limits can give clarification by narrowing both the extensiveness and the number of goals to be met. From meaningful goals manageable objectives can be

formulated. Objectives are usually obtainable, such as all tickets will be sold one week in advance of the event, or the operating budget for one year will be raised by X amount of dollars. Objectives usually list the criteria that in turn measures the success of the event. By having input from the entire board and planning committee, objectives can establish both primary and secondary importance by taking a second step: that of actually prioritizing the importance of each suggestion.

The value of both the goals and objectives cannot be underestimated. The time taken to name, define, clarify and prioritize insures that everyone will understand the project contains realistic expectations and all involved will be moving in the same direction! Objectives often help in defining/limiting the need, function, authority and responsibility of the committees. Where goals may be as broad as improvement of the arts or cultural experiences for the city, objectives give specific direction such as a direct increase in the number of performances of the symphony, or even, increase the attendance of the visually impaired at symphony concerts.

2. *Pre-Planning*
This is the time when all the possibilities that would fulfill the goals and objectives are discussed at length. No options are held, all are presented. At this point there are no limits, no boundaries. Yet, from these discussions usually come a certain number of limitations which assist in eliminating some possibilities. Exploration and brain storming are most valuable.

3. *Selection of the Event*

The complete plan of what, why, who, where, when and for how long is determined by *all* those who need to be involved in making the decisions. Team playing, team support starts here. The selection process is made only once. The initial planning of the event should then be in place with the necessary work divided into task areas managed by committee or units each headed with a strong leadership personality. People, the *right people* for the job, become extremely important. Further planning and development are welcomed in the committees as the ability to contribute by all people involved helps to create ownership of the event within the volunteer corps.

4. *Executing the Event*

Checks and balances are always desirable. Even though most areas will go smoothly, usually in each event there will be a glitch or glitches only fate seems to plan! Here the Professional Volunteer is indispensable, as it is the experience and innate senses that often offer the solution.

A good chairman or worker with responsibility often has thought through ahead of time "what ifs"; what if the flowers wilt or are beyond bloom stage -- the solution -- use balloon bouquets!

A system of rewards can enhance in the generation of continued interest and genuine enthusiasm. This can be as simple as announcements at meetings or in newsletters, invitations to special parties or a travelling trophy.

Adequate time for everything from setting up to taking down is just as important as adequate working personnel.

5. *Evaluation*

Often overlooked, but necessary to prevent the reinvention of the wheel, is the evaluation of all parts and functioning of the project or event. An honest critique is a most valuable and powerful tool. Evaluation should be on-going, immediate and complete. The day or two after the event is ideal. Enthusiasm is high, yet exhaustion has not set in! Both the positive and negative points should be recorded with enough detail to help explain why something worked while other things did not. The final "wrap up" often leaves the workers of a well coordinated function with a feeling of satisfaction, a feeling of appreciation for the work and effort involved and a feeling of wanting to volunteer next time to continue where this project ended.

Time Line Charts

Borrowed from industry are the time line charts. The concept entails dividing the time available for the entire project into units necessary for the carrying through of the event. The time line charts are a vehicle for communication -- communication which is <u>so</u> vital and necessary for a successful project. Time line charts are graphic reinforcements of how certain activities do overlap, how certain areas of planning/work must be finished before other tasks can be begun. Limits are hard to accept if sprung on people, yet a complete understanding from the beginning of how things should fit does assist. Time line charts clarify progress by graphically showing when work in each unit would begin and when it should be completed. Units that could be included are:

Goals and Objectives

Preplanning

Decision of the event

Committee selection

Basic arrangements

Progress reports

Final arrangements

Publicity campaign

Reservation period for attendees

Set up

Event

Evaluation

Appreciation event for volunteers

A major problem most groups face is becoming behind in the available time based on the preplanned schedule. Time line graphs should be displayed in areas where working meetings take place and through individual handouts that are given to each committee and each worker. A simplified example follows:

	January	February	March	April	May	June
Establishment of goals & objectives	━━━					
Pre-planning		━━━━				
Selection of the event			━━			
Carrying out the event			━━━━━━━━━━━			
Evaluation					━━━━━━━	

Each unit is essential yet the one often overlooked is evaluation, therefore its inclusion on the time line chart is imperative. Evaluation cannot be underestimated. Each facet or unit needs to be examined individually. For example:

Time

> Was it sufficient?
> Was the emphasis of each time unit correct?
> Was it too long?
> Did it fit the event?

Philosophy

> Was the event too ambitious?
> Was it too large, covering too may objectives?

Involvement of people

> Were more volunteers needed?
> Should fewer volunteers be involved in order to simplify the decision making process?
> Should people be used in a different arrangement?

Goals

> Were the major goals met?
> Were the goals too restrictive, too domineering?
> Was creativity stifled?
> Were the goals too open ended?

A survey of all people involved should be undertaken if at all possible. Workers usually have excellent suggestions. No final report should be considered complete without the final recommendations.

The most successful events -- those that raise the largest amounts of funds, those which are unique, or those that generate increased awareness for a specific cause, were planned, executed and evaluated as if these were the activities of commercial profit-making ventures. Not-for-profit organizations can no longer afford to make less than optimum use of their volunteer resources. Techniques used in the commercial world need to be incorporated into fund raising endeavors. This trend is just beginning and as more working men and women continue their volunteerism, our fund raising methods will become increasingly more sophisticated and efficiently managed. This does not mean the fun and enjoyment of volunteering will be lost, but that the pleasure and commitment of giving of one's time will more often result in successfully reached goals.

The Schools and Volunteering

The public schools are aiding in the growth of the volunteer independent sector. The idea for mandatory community service as a condition of graduation was first made in the public schools by a North Carolina School of Science and Mathematics in 1979. All students are required to spend four hours a week in community service (day care centers, hospitals, nursing homes or tutoring children in disadvantaged schools) and four hours a week in school service (working in the cafeteria, maintaining the library or raking leaves). In other states, Department of Education planners are also now considering mandatory community service as a condition of graduation. This idea is not new to private schools as a large number have required community service as a condition of graduation for many years.

One of the most important roles of higher education today is not just to educate students to academic and professional competence, but to give them the opportunity of serving the nation's needs through internship opportunities that earn

academic credit toward graduation. One of higher education's basic jobs is to ensure that the American people understand that there is this third way by which we, the independent sector, address national problems and aspirations. Alan Pifer, until recently, President of the Carnegie Corporation of New York, went through about 50 textbooks used in history, civics and social studies in elementary and senior high schools and in colleges and universities, and found no reference to volunteers or voluntary and philanthropic organizations. A student can go through a good education and never really grasp what this third sector means to us as people.[1]

In our study we found that Professional Volunteers learned the importance of volunteering in their youth. Obviously, our awareness of voluntarism must begin early. It is not a subject in school that replaces other important studies -- it is extra curricular by its very nature. It is done on "one's own time", yet can be prompted through schools at no cost.

One Example of a Successful Project

On June 17, 1988, Lecturer Kristine Anderson Peterson from Western Washington University witnessed the success of the preplanning and guidance she had given to approximately fifty fashion marketing university students as seven hundred people paid $15.00 per person to see the showing of the fashions from the Western Washington Apparel Design students at the recently refurbished Union Station in Seattle. Anderson adapted the management techniques gleaned from her Masters of Business Administration degree to gently guide, aid and encourage the student selected as general chair and the six student committee chair/faculty advisors, all volunteer. Anderson developed a time line graph for planning that may be used in the future.

OCTOBER / NOVEMBER

1. Facilities to be considered for the event are selected, and approval from the university obtained.

2. Faculty advisors for each committee are selected.

3. The responsibilities for each committee are established.

DECEMBER

1. Student committee heads and members are established.

 a. Students are encouraged to nominate themselves.

 b. Faculty make final decision acting much as a Board.

2. Student committee heads meet with faculty advisor to start planning and prepare to kick-off the organization of the show in January.

3. Facility where event would be held are approved and deposit paid.

JANUARY

1. All committee heads and advisors meet in large meeting. Establish meeting dates and times for rest of year, and responsibilities for each task.

2. Decide on theme and show colors.

3. Decide on time, food service if used.

4. Students obtain bids on all services, paper and all other expenditures.

5. Approve fundraising plan and begin. (Aim to end fundraising in April)

6. Start first fundraising project.

7. Establish ticket price.

8. Establish ticket policy.

9. Each committee head meet with members to delegate assignments and establish meeting times.

10. Send project plan and budget to department chair - secure approval.

FEBRUARY

1. Finalize theme artwork.

2. Continue candy sale with second push for sales.

3. Start to sell raffle tickets.

4. Contract with light and sound technicians, videographer, photographer and other vendors.

5. Send letters to last year's advertisers to see if they would like to advertise in the program again.

6. Send letters to new potential advertisers.

MARCH

1. Send letters to modelling schools to recruit models.

2. Begin to print tickets, invitations, response cards, return envelopes and posters.

3.. Close raffle ticket sales and draw for prizes.

4. Send patron letters for donations.

5. Begin to sell advertising for the program to those organizations and people that did not respond to mailings.

APRIL

1. First garment review with hanger ready garments.

2. Program garment descriptions organized into categories for the show.

3. Close candy sale.

4. Begin to complete material for the program, including: Letters of welcome from department chair, garment descriptions, names of those involved.

5. Validate mailing list for invitations.

6. Contract hair/make-up artists for donations.

7. Start to work on music based on garment categories.

MAY

1. Outline three day schedule for the day prior to the show, the show day and the day after the show. Include every detail that each committee must deal with and the responsibilities on these days.

2. Distribute the three day schedule to students and faculty.

3. Start rehearsals at the end of the month.

4. Address invitations.

5. Mail invitations and complimentary tickets.

6. Pay deposit on catering.

7. Make final adjustments on staging, including: Backdrop, decorations, table decorations, etc.

8. Close the selling of advertising in the program.

9. Compile press kits and distribute three weeks before the show.

10. Compile all program information.

11. Open ticket sales three weeks prior to event.

12. Meet with choreographer to discuss concepts.

13. Arrange for dressers for the show.

JUNE

1. Last garment review for inclusion into the show.

2. Arrange backstage food at the event for models and designers the day of the show.

3. Coordinate timing with hair stylist and make-up artists.

4. Confirm all vendors and their services.

5. Determine and confirm floor plan with caterer.

6. Draw names for seating.

7. Organize tickets and number tables.

8. Brief hostesses on seating guests.

9. Run three more rehearsals before the show.

10. At dress rehearsal establish backstage policies for before and during the show.

11. Give final count to the caterer 48 hours prior to the event.

12. Print and assemble program.

13. Follow up press kits with phone calls to television and radio stations, and newspapers.

14. Sell tickets!

15. Get rolling racks for garments behind the stage.

16. Have each committee head and faculty advisor evaluate the show.

17. Meet with students after the show to tie up loose ends.

18. Write evaluation of the show and include recommendations for the next year.

19. Distribute video tapes to those who purchased a copy.

EXAMPLES OF WORK SHEETS DISTRIBUTED TO ALL PERSONS
WORKING ON THE EVENT

THURSDAY, JUNE 16TH

12:00 NOON BUILDING ACCESS

 PARTICLE BOARD DELIVERED

3:30 PM ATTACH PARTICLE BOARD

 PAINT FIRST COAT OF PARTICLE BOARD

 SET-UP BACK DROP

 DELIVERY OF RACKS

 SET-UP DRESSING ROOMS

6:30 PM DRESS REHEARSAL

9:30 PM FINAL PAINTING OF PARTICLE BOARD

FRIDAY, JUNE 17TH

12:00 NOON BUILDING ACCESS

DESIGNERS DELIVER CLOTHES (MUST BE

DELIVERED BY 1:00 PM)*

3:00 PM MODELS ARRIVE*

3:30 PM CATERER WILL HAVE TABLES SET

PLACE TABLE DECORATIONS AND NUMBERS

5:00 PM BACKSTAGE FOOD

SET-UP VIDEO AND POSTER SALES TABLE

SET-UP WILL CALL TABLES

6:00 PM HOSTESSES ARRIVE

6:30 PM HOSTESS BRIEFING

WILL CALL BRIEFING

PRESS BRIEFING

7:00 PM FOOD IS SET

DOORS OPEN

*USE SIDE DOOR OF UNION STATION

SHOW SCHEDULE

7:00 PM DOORS OPEN

BUFFET / BAR

8:00 PM OPENING REMARKS

WELCOME / TRIBUTE TO INDUSTRY

DEDICATION / INTRODUCTION OF FACULTY

UNIVERSITY REPRESENTATIVE

8:10 PM GARMENTS

8:55 PM CLOSING REMARKS (AT EXIT OF LAST MODEL)

INTRODUCTION OF COMMITTEE HEADS

INTRODUCTION OF DESIGNERS

THANK YOU AND INVITATION TO DESSERT

9:05 PM COLLAPSE OF EXHAUSTION

DESSERT BUFFET

DESIGNERS REMOVE GARMENTS, ACCESSORIES

CLEAN-UP OF ALL VALUABLES

9:00 AM TEAR DOWN

EVALUATION

The evaluation will continue for several weeks culminating in a final report which will include the views and suggestions of many of the volunteers.

The success of the event is measured in many ways, yet no student or faculty member received any remuneration and many of the outside services were donated. The students' voluntary work produced an evening that all who participated or attended will long remember.

ROOM FOR ALL OF US

While exploring the entire area of volunteering for the arts, it became fairly well established that volunteering appears to be an American phenomenon. Yet, what is even more encouraging is that there is room for everyone to donate their time and skill. A volunteer, to be successful, needs only a demonstrated interest, specific experience / knowledge in at least one element to share, and available time. All volunteers need to be alerted to the expectations ahead, as success comes from understanding these expectations.

Volunteering can, and should be a wonderful positive experience!

REFERENCES

Chapter Four

1 *Origins, Dimensions and Impact of America's Voluntary Spirit,* paper by Brian O'Connell, Independent Sector, pg. 5.

CHAPTER FIVE

FUTURE TRENDS AND EMERGING ROLES

The necessity of using volunteer efforts for hours of work and monies raised will continue in the future. However, the needs are going to increase and the methods used by volunteer efforts will evolve into new avenues. Corporate donations may match the Medici's of old, but still will not meet the increasing need. The outcomes stemming from the successes volunteers have had will only increase the expectation of what volunteers can accomplish.

New specialized professionals educated through the Bachelor and Master Arts Management university programs of study are emphasizing the ability of professional fund raisers and legislative arts advocates to bring large funding commitments to arts causes. These causes often require hundreds of thousands of dollars to be raised. The volunteer coordinator, a person who specializes in matching a person and his or her interest to the job needing to be done, is also a new area of specialization. By matching person to task, a volunteer is more likely to be kept interested and feel the work is indeed worthwhile. Volunteers may request specific experiences through regional volunteer registries.

However, most important in the future will be the recognition and the appreciation of the Professional Volunteer, that person whose efforts causes things to happen -- no matter how much effort is required.

Professional Fund Raising Firms / Consultants

The American Association of Fund Raising Counsel is an organization that was formed in 1935. It is composed of approximately thirty-two professional fund raising counseling firms in the United States, the largest being Ketchum, Incorporated, located in Pittsburgh. Techniques used by the Association are not a new trend but are described in this chapter because they are a widely recognized fund raising avenue for arts organizations. The demand for services provided by fund raising counseling firms is particularly strong in a time when earned revenues rarely cover the expenses of running not-for-profit associations.

In 1935, nine established professional fund raising counseling firms joined in forming the American Association of Fund Raising Counsel, Incorporated. Their primary purpose was to bring order into a field that was disorganized at that time and, in some instances, misunderstood and distrusted. The first act of the Association was to adopt a code of fair practice which is now widely accepted as a standard for professional conduct in fund raising. The Association seeks to carry out the following program:

- To maintain high standards of ethics and professional techniques in fund raising counseling.
- To study and identify economic and social trends in American philanthropic areas,
- and to share this information with the general public.
- To foster and encourage professional training in fund raising techniques.
- By example, and through strict adherence to the Association's code of practice, to discourage unethical and unprofessional practitioners.

\- To provide a center of information on philanthropy which is made available to related groups, non-profit institutions and agencies, students, the general public and others engaged in studies of philanthropy.[1]

According to Charles Feldstein, President of Charles R. Feldstein & Company, Incorporated, which is a member of the American Association of Fund Raising Counsel, there are two things that professional fund raisers do exceptionally well:

1. *Consult* on the *organization* of fund raising;
2. *Consult* and *manage* capital drives.

Professional fund raisers rarely enter an organization to run its fund raising project... they assist instead with its organization and management. They are primarily consultants who have had exposure to varied and numerous successful and non-successful methods of raising monies. They also are adept at developing fresh ideas, or adapting a plan successfully applied elsewhere to meet their client's needs. They often assist in the hiring of Development Directors to coordinate fund raising projects and assist in the process of job definitions for both the Director and his staff.

Professional fund raisers rely heavily on volunteers within client organizations but primarily deal with volunteers at the Board level. Feldstein feels strongly that volunteers are the critical ingredient which turns his ideas for projects into tangible results. The quality of these results depends completely upon volunteer enthusiasm for the project as much as the quality of the ideas themselves. For this reason, the industry practice for consultant consultation is to be

remunerated on an agreed fee schedule rather than work on a commission. Volunteers participate more readily when they feel their contributions aid the project's goals instead of helping the consultant reach his goal. "This method works better in the volunteer mindset," states Mr. Feldstein.

As both the quantity of arts organizations grows and their budgets expand, the available dollars per entity diminishes. Volunteer awareness of professional fund raisers and professional fund raising firms will certainly increase and volunteers at the board level will become more directly involved in fund raising efforts in addition to setting policy and deliberating operating issues. They will find themselves directly involved with outside consultants and fund raising projects brought to it by board members and increased organization staff. The future trend will be that professional fund raisers and volunteers will find an increased mutual need for each other in their common goal of support for arts organizations.

Volunteer Registries

Volunteer registries have been described by Bob Herzog of the Montgomery County Volunteer Registry as employment agencies that place unpaid employees. Volunteer registries, another rather recent entity, function as central clearing houses that screen applicants for qualifications and make referrals but leave the final selection to the agency needing workers.

In the process of interviewing highly successful arts organizations personnel, the Maryland Montgomery County Volunteer Registry was identified as an outstanding source of motivated, highly skilled volunteers who desired to use their skills for more than the typical job of envelope stuffing.

What makes this volunteer registry so unique? Montgomery County is located adjacent to Washington, D.C., covering a 500-square-mile area with 600,000 inhabitants. Director Herzog of *The Montgomery Volunteer Directory* describes the area as having mainly middle class incomes, yet with a high level of expectation for the quality of life due to the education and experience levels characteristic of persons living in the area.

The Montgomery County Volunteer Registry began in 1975 when both private and government agencies made known to the county organization the need to have an agency advertise and pre-screen technical people who could give skills and talents to projects that needed accomplishing but had no funding. It was recognized that benefits for the volunteer existed in the form of being able to experience use of their skills in another environment. This could lead to the opportunity for promotion of the self-directed, upwardly mobile person in attaining personal goals. Early in the development of the registry, the opportunity for those persons who anticipated early retirement to try other fields was recognized. The Montgomery County Volunteer Center is funded by the Montgomery County Department of Family Resources through the local Chapter of the American Red Cross. Eileen Cackowski, Director since 1986, is an employee of the Red Cross Association. The Center is considered a private agency and services strictly Montgomery County.

Herzog has noted changes in the make-up of persons within the volunteer pools in the last ten years. When the agency began in 1975, the traditional registree was the person who had been in the home for a number of years, the housewife who was volunteering time away from home -- testing the workplace for the first time. That wave of volunteers has passed. A new kind of volunteer has emerged -- a

person who works for gainful employment full time yet desires to return his or her part to society. Gone is the image of only the female volunteer. Men give their time with the same ease today. The volunteers tend to be highly educated with 73% between the ages of 20-49. Most volunteers are working full time so the hours for volunteering tend to be in the evenings and on weekends.

The Volunteer Directory personnel insist that all placement persons must be treated the same as paid persons. Volunteers are human resources; volunteers have measurable value. The Montgomery County Volunteer Registry with three paid staff and thirteen volunteer placement counselors serves 350 agencies -- representing all fields -- placing approximately 13,000 volunteers each year. Each volunteer is furnished with three referrals. The use of skilled volunteers will certainly continue as the monies saved are realized. The identified talent with high performance standards will allow even larger accomplishments in hopefully shortened periods of time. Cackowski credits the public service announcement programming in June 1987 for assisting in attracting the high number of volunteers. "June Connection" focused approximately one million dollars of free air time at all times of the day on the importance of volunteering with the Montgomery County Volunteer Center.

Approximately 450 volunteer registries exist today in various parts of the United States, but the Montgomery County Registry is one of the most worthy of recognition.

When turned to the future of voluntarism, Herzog predicted:

1) Master's Degree study will include effective use of volunteers as a part of all projects -- effective volunteer management has come of age.

2) Volunteerism will develop a sophisticated philosophy; volunteers will take on entire responsibilities.

3) Volunteers are surfacing as a unique, positive contributing phenomena to the community.

Volunteering for special causes has become a leisure time activity in the last twenty years of the century. Volunteering allows a love of the arts to be kept alive without the expectation, need or anguish required to support one's self through arts related activity. Volunteering gives opportunity to enrich one's life, to have an exciting, rewarding avocation as well as vocation.

What must be addressed, however, is the removal of the threat felt by some paid personnel who often do not understand that the volunteer is exactly that; the volunteer wants and receives other forms of compensation. The arts paid employee must be made aware of the natural marriage of the paid staff with the skilled volunteer. Both are needed and necessary.

Undergraduate and Graduate Study

The use of organized volunteers will not only continue in the future, but will be increasing. In the late 1960's and the early 1970's, the college bachelor's degree began to appear which offered degree candidates the opportunity to formally study extensive management philosophy theories and technique skills directed toward the arts. Many programs included the opportunity to explore some aspect of the

potential related to efficient use of volunteers. In reviewing the philosophy and course requirements in the programs, the most extensive concentrations of required courses in the bachelor degree programs was in management principles and management skills.

The number of colleges and universities offering these programs appears to be changing along with the content of the course study. Discovering colleges and universities that offer these degree programs was more difficult than anticipated. After requesting information from fifty-one identified programs and analyzing eight undergraduate programs plus five graduate programs, the basic philosophy found encourages development of those students who desire to combine both art and business for administrative and entrepreneurial roles. The development of this applied area took place mainly during the 1970s; the titles given these programs of study vary widely and a natural evolvement appears to have taken place in that some of the courses or course theories have become part of broader management or fine arts major programs of study. Columbia University of New York includes courses in book publishing, motion pictures and the music recording industry as well.

The effective management of all resources has become particularly important recently because of the increased awareness of the added benefit volunteers can give to an arts organization, whether those organizations specialize in theatre, opera, symphony or museum management. By offering a formal study, these institutions help prepare arts managers who will be able to yield optimum results for their arts organizations using all variety of resources including the unpaid Professional Volunteer. Managing people as a human resource to accomplish arts related goals is a trend of the future.

REFERENCES

Chapter Five

[1] *Giving USA,* 1984 Annual Report, American Association of Fund Raising Counsel, Inc., inside cover.

OUR FINAL THOUGHTS ABOUT VOLUNTEERS

We have no doubt that volunteering will be ever more important as we approach the 21st century because of both the increased number of arts organizations and the increased interest in the arts by the general population. Volunteering in its basic form is communicating or networking the project or production; in other words, the synchronizing of actions so a measurable difference is accomplished.

During the past six years we have been studying volunteering, six major summary points on volunteerism have developed. These are:

1. Volunteering has a role in every person's life: ONE PERSON CAN MAKE A DIFFERENCE. The outcome in terms of money raised is really quite phenomenal. These actions need not only be continued but more openly encouraged. Positive volunteer effort knows no boundaries of age, education level or income range. Everyone can be included in working toward a goal.

 "I have come to believe that what I do can make a difference."
 Lenore Rukavina, Northern Minnesota

2. The Professional Volunteer is indeed precious! Perhaps the most extraordinary characteristic of this person is their ability to focus and concentrate on their task and their goal. Professional Volunteers should be identified early. They should be both encouraged and challenged as perhaps these are the pragmatic people who really believe the impossible just takes a little longer!

"Decisions in our country are not made by quantitative statistics, they are made, one by one, by specific individuals. Thus, it is the role of the qualitative individual -- the leader -- to act so as to bring greater quality to his or her own life and to the lives of others."

Justice Sandra Day O'Connor

3. Objective research related to volunteerism is essential. Practices from business management including market surveys needs to be adopted for even more efficient and productive results. Increased time should be present in the planning stage. This should include idea generation and actual researching of events already held elsewhere that are related. Practical considerations such as matching the numbers of volunteer hours needed with the number of actual workers or supervising the special talents of the volunteers with required necessary tasks could help to eliminate frustrations that often arise if too many people are asked to do more than they desire or do things in which they do not have an interest. In other words, the level of outcome generation per worker per time unit needs realistic appraisal or calculations. Adequate research methodologies should help to reduce time expenditure.

"Volunteering is fun and provides an exciting social life, but it is also serious business."

Carolyn Bockhorst, Louisville, Kentucky

4. Evaluation of completed projects should always be the final step in the planning and executing process. The most successful events relied on immediate evaluation; the more intense the better. This removes the

possibility of allowing inertia to cause the same mistakes to happen year after year. Completion of any event should automatically trigger a complete appraisal, analysis and evaluation.

5. Volunteers coming together from diverse backgrounds make things happen! Volunteering in groups make things occur as new enthusiasm and new ideas emerge. The group can draw on rich past experiences yet melt together variables for an entirely new concept that one person is not likely to have.

"A comradery develops in volunteer work that differs from the work place."
Mary Ann Champion, Seattle, Washington

6. Volunteers of today and in the future want to balance their lives by giving back to the community. These are active people in their personal life as well as professional life.

"You are not here merely to make a living, you are here in order to enable the world to live more amply, with greater vision, with a finer spirit of hope and achievement. You are here to enrich the world, and you impoverish yourself if you forget the errand."
Woodrow Wilson

Again, volunteering is here to stay and rightfully so. Long live volunteering and the Professional Volunteer!

BIBLIOGRAPHY

"Vantage Point, Issues in American Arts," *The Magazine of the American Council of the Arts.*

American Association of Fund Raising Counsel, *Giving USA.* 1979, 1983and 1984 Annual Reports.

Americans and the Arts: A Survey Of The Attitudes Toward And Participation In The Arts and Culture Of The United States Public, New York, New York: National Research Center for the Arts, 166 pages, 1975.

Ames, Amyas, National Committee for Cultural Resources Report; Americans and the Arts, August, 1975, Associated Counsel for the Arts, pg. 12.

Brisken, L. *Arts and the States: A Report of the Arts Task Force National Conference of State Legislators,* Denver, National Conference of State Legislators, 1981.

Commission on Private Philanthropy and Public Giving, 1975.

de Tocqueville, *Democracy in America,* A. A. Knopf: New York, 1945.

de Tocqueville, Alexis, *Democracy in America,* Vol. II, A. A. Knopf: New York, 1945.

Dimensions of the Independent Sector: A Statistical Profile, V.A. Hodgkinsons & M.S. Weitzman, First Edition, p. 63.

Encyclopedia Brittanica, Volume 7, Chicago, William Berton, 1966.

Giving USA, 1984 Annual Report, American Association of Fund Raising Counsel, Inc.

Giving USA, Estimates of Philanthropic Giving in 1986 and the Trends They Show, A publication of the American Association of Fund Raising Counsel Trust for Philanthropy, 1987.

Hesburgh, Theodore H., "Reflections on Voluntarism in America," April 21, 1980.

Hodgkinson, V.A. and Weitzman, *Dimensions of the Independent Sector: A Statistical Profile*. Washington, D.C., Independent Sector, 1984.

Hodgkinson, V.A., and M.S. Weitzman, *Dimensions of the Independent Sector: A Statistical Profile*, Independent Sector, Second Edition, 1986, pg. 3.

Independent Sector Annual Report, 1981, p. 13.

Independent Sector, 1980 and 1981 Annual Report.

Independent Sector, the First Five Years, 1980-1985.

Kirstein, L. *Dance, A Short History of Classical Theatrical Dancing.* Brooklyn, NY: Dance Horizons, Inc., 1969.

Klein, Julia M. "Volunteerism" *Working Woman*, 7:67-70, June 1982.

Kraus, R. *History of the Dance in Art and Education.* New Jersey: Prentice-Hall, 1969.

Maslow, Abraham. *Motivation and Personality,* Harper, 1954.

McManus, Dancing for Disease, *Forbes,* 1983, pg. 132.

National Assembly of State Arts Agencies, Washington, D.C.

Origins, Dimensions and Impact of America's Voluntary Spirit, paper by Brian O'Connell, Independent Sector, p. 7.

Perloff, Harvey. *The Arts.*

Shaping Policy on the Arts (American Town Meeting on the Arts in Washington, D.C. W. Yates, Chr. Cent. 98: 1046-8, October 21, 1981.

Smith, David Horton, *Voluntary Sector Policy Research Need,* Washington, D.C., January 1982.

The Association of Junior Leagues, Inc.

United States Department of Commerce/Bureau of Economic Analysis, "Survey of Current Busines," Vol. 65, No. 7, July, 1985.

Waleson, Heidi, Professionalization: Orchestra Volunteers, *Symphony Magazine,* October/November, 1984.

Wexler, Jacqueline, President of Academic Consulting Association in New York
 City.

Papers:

O'Connell, Brian, "Origins, Dimensions and Impact of America's Voluntary
 Spirit", September, 1984.

Hesburgh, Theodore H., "Reflections on Volunteerism in America", April 21,
 1980.

Yearbooks:

American Symphony Orchestra League, *Gold Book*

Opera American, *Special Event Fundraisers*

Newspaper Articles:

Brinster, Freddie, "Federal Deficit Puts Lid on Arts Support." *Bellevue
 Journal American,* September 14, 1982.

Curtis, C., "Black-tie in Soho," New York, *New York Times,* p. 20, October 25,
 1982.

Doyle, D., "Socialist Sweden Tries to Reinvent Philanthropy," *Wall Street Journal*, April 17, 1984. p. 34.

Los Angeles Times, Los Angeles, Section IV, pp. 1, 14, 15, December 26, 1983.

New York Times, New York, pp. 20, 21, May 8, 1982.

BIOGRAPHICAL SKETCH

ABOUT THE AUTHORS

Rosalie R. King, PhD, holds the position of Professor and Chairman at Western Washington University. In addition to her professional teaching and publication activities, she is also a regular volunteer.

Jacqueline Fluke is a volunteer who makes things happen! Her energy, vitality and genuine interest in improving her community has enabled many Northwest organizations to experience new successes.